TOKYO
MINDSCAPES

Where to Go, When to Go, What to See

Photos and Text by

misaki matsui

MUSEYON
New York

Library of Congress Cataloging-in-Publication Data

Names: Matsui, Misaki, author, photographer.
Title: Tokyo mindscapes : 200 iconic scenes to visit : where to go, when to
go, what to see / Misaki Matsui.
Description: New York : Museyon, [2019]
Identifiers: LCCN 2019007424 | ISBN 9781940842325 (pbk.)
Subjects: LCSH: Tokyo (Japan)--Guidebooks.
Classification: LCC DS896.38 .M28 2019 | DDC 915.2/1350412--dc23
LC record available at https://lccn.loc.gov/2019007424

Published by:
Museyon Inc.
333 E. 45th St.
New York, NY 10017

Museyon is a registered trademark.
Visit us online at www.museyon.com

ISBN 978-1-940842-32-5

Printed in China

TOKYO
MINDSCAPES

東京心風景

Table *of* CONTENTS

TOKYO, MY LOVE

Home to more than 13 million people, Tokyo is the world's largest metropolis and is always changing, as the latest technology of the future sits side by side with glimpses of old Japan. My inspiration for this book comes from three different perspectives on my favorite city.

I want to introduce the beauty of Tokyo's four seasons and the cultural events related to each. Tokyoites' daily lives are connected to the seasons, and I think it would be fun for you to enjoy Tokyo from the native residents' point of view.

I also want to show places of interest close by, where to eat and what the local dishes are, as well as popular and traditional souvenirs to make your visit complete.

As an artist, I not only want to show visitors beautiful landscapes, but I also try to show a state of mind—to experience these beautiful places as places to heal the spirit and find peace in the big city of Tokyo—especially for people who need a rest from their very busy lives.

It took many tries to get the perfect photos. I took the first train to see the tuna auction at Toyosu Fish Market. The weather was too unstable to predict the peak bloom period, so I had to make three visits to the same place at Chidorigafuchi. It took a couple of trips to Enoshima and Lake Kawaguchi-ko to see Mount Fuji with no clouds.

Creating Tokyo Mindscapes required from me both some effort and a little luck, but it also rewarded me with a lot of excitement and enjoyment. I hope this book helps you to find your own Tokyo Mindscapes when you visit Tokyo!

—misaki matsui

SPRING

haru

Tokyo's Massive "Central Park" in the Center of the City Is Three Parks in One: French Formal, English Landscape, and Japanese Traditional

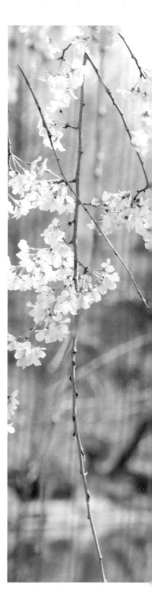

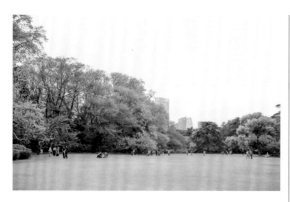

新宿御苑

SHINJUKU GYOEN

One of Tokyo's largest and most popular parks, Shinjuku Gyoen is on the site of a mansion belonging to Lord Naito, a "daimyo" (feudal lord) of the Edo era, and was transferred to the Imperial Family in 1906. The park was almost completely destroyed during World War II, but was rebuilt and reopened in 1949 as a public park. A massive 144 acres (58 hectares) in size, it is comprised of three different types of gardens, a French formal garden, an English landscape garden and a Japanese traditional garden. This beloved refuge for Tokyoites is in the center of the city, like Central Park in New York. People enjoy picnicking under the cherry blossoms (*sakura*) in spring surrounded with views of skyscrapers. Autumn leaves are beautiful here too.

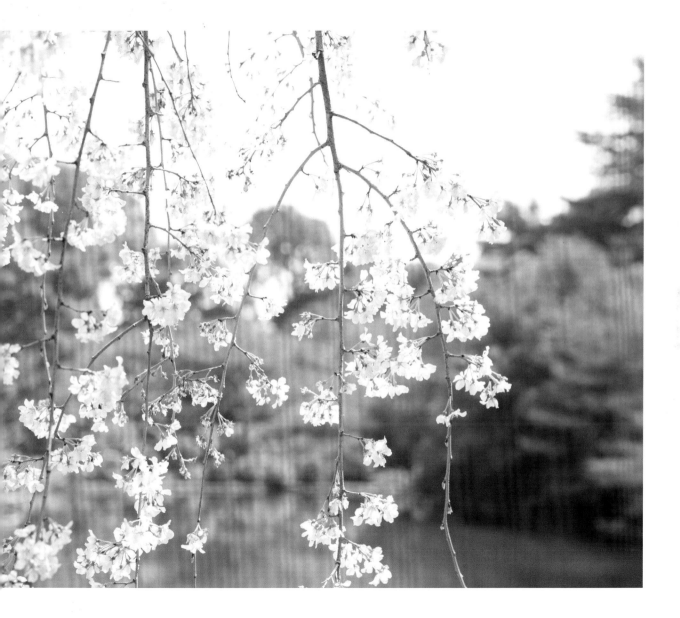

This towering bronze buddha (*daibutsu*) on the grounds of Kotoku-in reaches a height of 37 feet (11.3 meters). The statue, which dates from around 1252 in the Kamakura period, represents Amida Buddha, who guides people to the Pure Land. It was once gilded, and you can see traces of gold leaf near the statue's ears. Storms in the 1300s destroyed the building covering the statue, and since then it has stood in the open. For a small donation you can go inside. Kotoku-in is just a 5 to 10-minute walk from the Hase Station of the Enoshima Electric Railway. The small-town vibe of Hase and the narrow streets that lead from the station to the buddha are a treasure trove of souvenir shops, traditional eateries and local produce worth exploring. Don't forget to have a *hato sable* (cookie shaped like a pigeon) here as well.

鎌倉大仏殿
THE GREAT BUDDHA OF KAMAKURA /
KOTOKU-IN TEMPLE

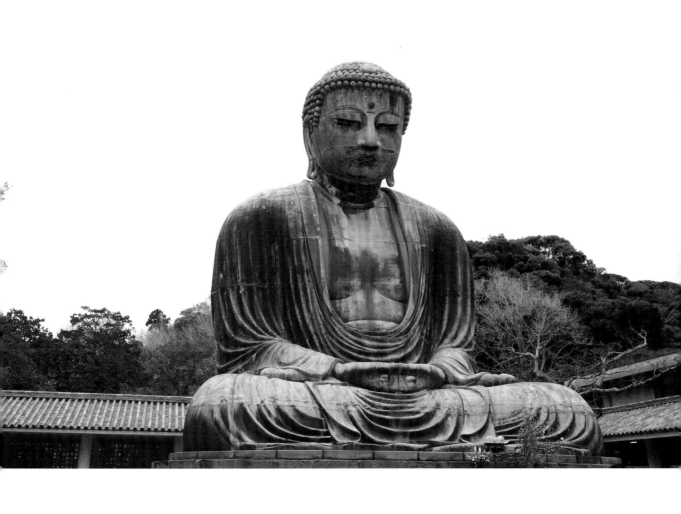

Enjoy a City Within the City in the Heart of Tokyo, Especially at Cherry Blossom Time and at Christmas

東京
ミッドタウン

TOKYO MIDTOWN

This mixed-use luxury development sits on a 19.4 acre (78,000 square meter) site in the Akasaka/Roppongi area, previously occupied by the Japan Defense Agency. The complex includes shops, restaurants, and residences, as well as The Ritz-Carlton Tokyo Hotel, the Suntory Museum (a modern space filled with traditional works) as well as a green area at Midtown Garden, and Hinokimachi Park, formerly the mansion of Lord Mori, a *daimyo* (feudal lord). When Sakura Dori (a cherry blossom street) is lit up in late March it is an enchanting sight with pink lit cherry blossom trees dotted against the buildings. In the winter, holiday lighting illuminates the complex, and this "Midtown Christmas" is an amazing sight. In this luxury spot, you can feel like royalty walking under the lit up trees.

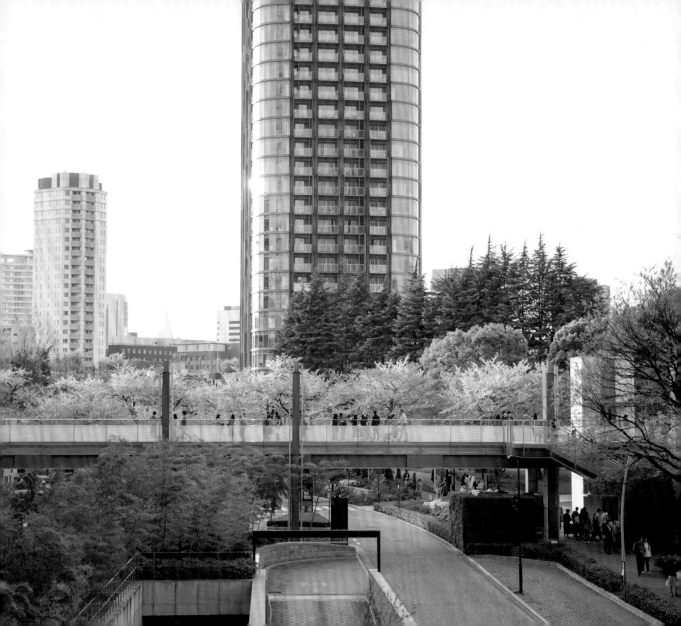

Come See One of Tokyo's Favorite Spots for Cherry Blossoms, Enjoy City Views From the Sky Garden

目黒川・
目黒天空庭園

MEGURO RIVER
& MEGURO SKY GARDEN

The Meguro-gawa River is one of the top cherry blossom spots in Tokyo. Along the Meguro-gawa, a tunnel of cherry blossoms (*sakura*) with Japanese lanterns appears from late March to early April. Walking the promenade along the Meguro-gawa from Nakameguro station to Ikejiri Ohashi station, you will find the Meguro Sky Garden, a stunning example of modern Japanese architecture. The Sky Garden is a beautiful, 1.7 acre (7,000 square meter) circular garden park built on top of Ohashi Junction, a structure that connects two major expressways. This secret garden is an amazing place to enjoy a bit of nature, and to see beautiful sunsets and night views of the city. It's worth going in the evening too. Being here makes me feel like I am in the Hayao Miyazaki animated film *Castle in the Sky*.

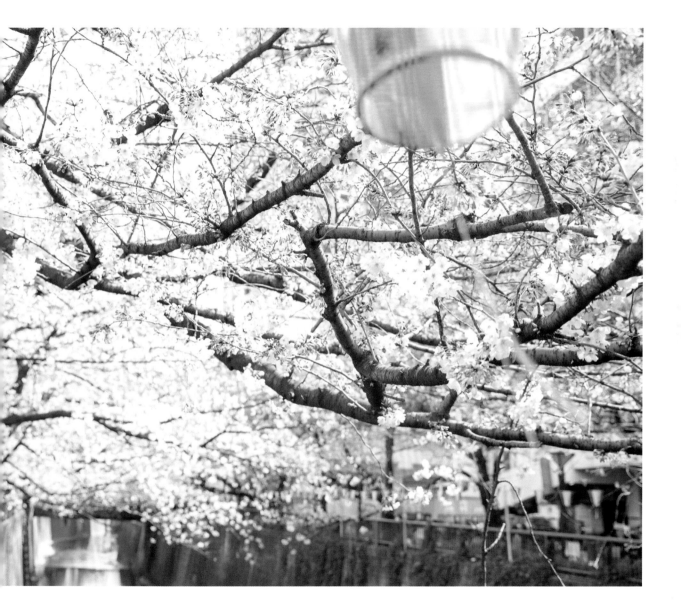

A Fashionable Place to Be: Along the Cobblestone Streets
Enjoy High-End Restaurants, Geisha, and French Cafes

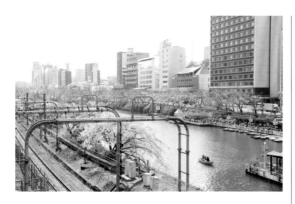

Kagurazaka is an elegant, traditional neighborhood near Iidabashi Station located on a sloping, cobblestone street. The area rose to prominence as a geisha district, *kagai* (*hanamachi*), in the Edo period. Located just outside the Edo Castle gates, it was a center for entertainment long into the Meiji period, and today, it remains one of Tokyo's places to be, with *ryotei*, traditional high-end Japanese restaurants and *geisha*. Since it is also home to a French expatriate community, many French cafes and restaurants can be found throughout the district. Along the Kanda River, Tokyo Suijo Club (Canal Cafe) was the first boat pier founded in 1918. Enjoy a glass of sparkling rosé on the floating terrace of Canal Cafe when you come to see the cherry blossoms (*sakura*) in spring.

神楽坂

CANAL CAFE / KAGURAZAKA

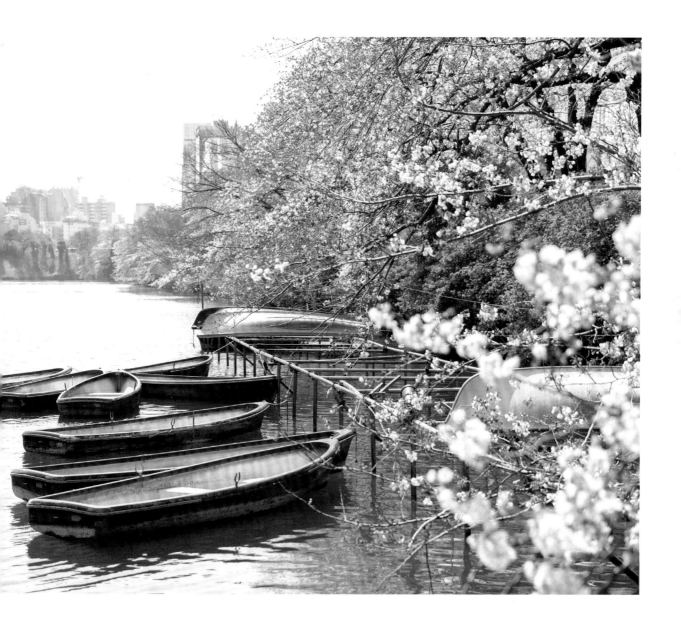

See Views of the City, and on Clear Days Mt. Fuji From Tokyo Tower, Then Explore the Buddhist Temple

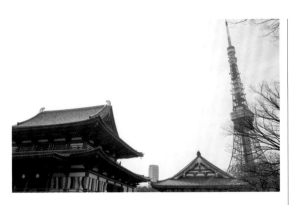

東京タワー・
増上寺

TOKYO TOWER
& ZOJO-JI TEMPLE

Tokyo Tower, built as a broadcasting facility in 1958, has come to symbolize the country's recovery after World War II. Rising to 1,092 feet (333 meters), it was the tallest tower in Japan until the completion of Tokyo Skytree in 2012. The top deck, at 819 feet (250 meters), offers views of the city below and, on a clear day, Mt. Fuji. Next to Tokyo Tower is Zojo-ji Temple, one of the seven head temples of Jodo Shu (the Pure Land Sect of Buddhism), founded by Honen, a Buddhist priest. Nearby is the mausoleum of Tokugawa Shoguns. The main entrance gate, the Sangedatsumon, dates from 1622, and has survived fires, earthquakes and wars. Don't miss this rare place to see both ancient and modern architecture, and come to Shiba Park in late March to early April to see the cherry blossoms (*sakura*)!

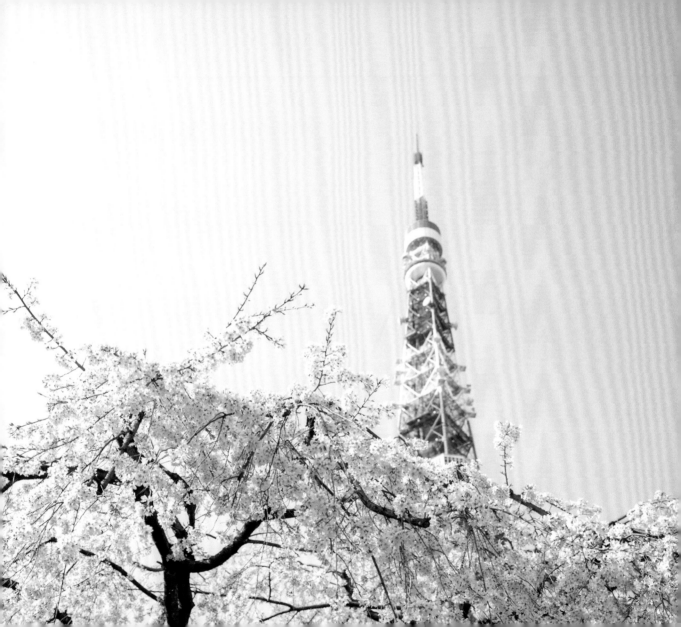

Rent a Boat and Explore the Moats of the Imperial Palace, a Beautiful Spot for Cherry Blossoms

The Imperial Palace (Kokyo) was the former residence of the Tokugawa clan in the Edo Period. After the Meiji Restoration in 1868, Emperor Meiji Tenno lived here, and the country's capital and imperial residence were moved from Kyoto to Tokyo. The 284-acre area is encircled by moats, and you can rent a boat. The lush cherry blossoms (*sakura*) along the Chidorigafuchi moat are among the most famous in Japan. Late in the season the moat's surface is almost completely covered in petals. Chidorigafuchi's path around the moat, with a 2,296-foot-long (700 meter) tunnel of cherry blossoms in the spring, is packed with people. Colorful boats float in Sotobori (the outer moat of the castle) and when the cherry blossom petals fall on them, it is like a fairyland. Walk along the path and celebrate spring, Japanese style!

皇居・千鳥ヶ淵

IMPERIAL PALACE
& CHIDORIGAFUCHI

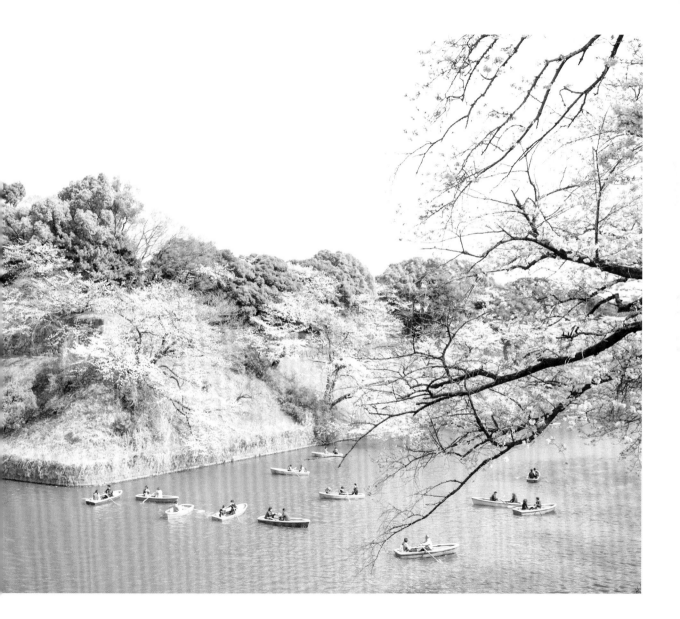

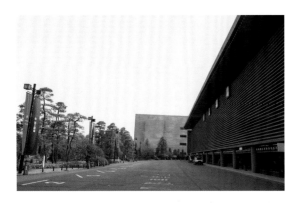

See Japanese Traditional
Performing Arts at the Only
Classical Theater in Japan

国立劇場

NATIONAL THEATRE OF JAPAN

Don't miss an opportunity to see some traditional Japanese performing arts. The theater (Kokuritsu Gekijo) was built in 1966 for the preservation and promotion of Japanese traditional arts, and this national theater performs only traditional Japanese arts. Designed by architect Hiroyuki Iwamoto, the exterior of the theater recalls the *Shosoin*, the ancient wooden storehouses in Nara. At the larger theater, *Kabuki, Buyo* (Japanese traditional dance), *Minzoku Geino* (folk performing arts) and *Gagaku* (Japanese court music) are performed, and the smaller theater features *Bunraku* (traditional puppet theatre), *Kabuki, Buyo, Hogaku* (Japanese traditional music) and *Minzoku Geino*. Don't worry if you don't understand Japanese, English-language audio guides are available for major *Kabuki* and *Bunraku* shows.

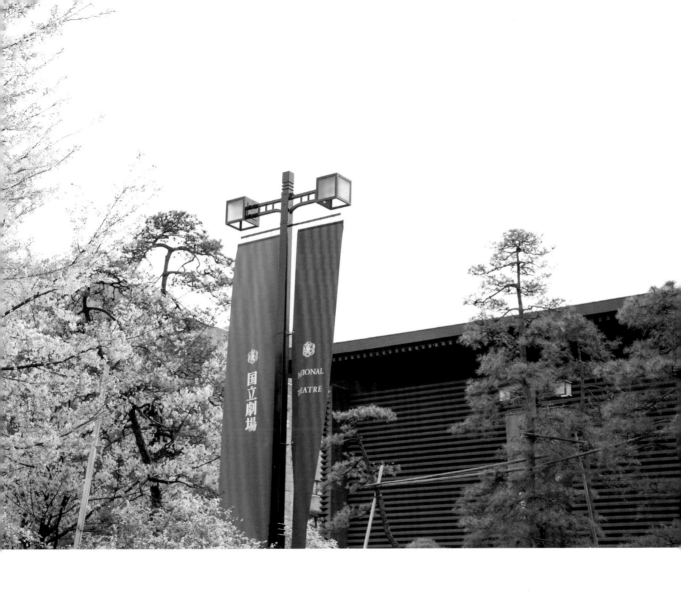

See the Beautiful Wisteria and Chrysathemum at the "Flower Shrine," Where Students Pray to Pass School Entrance Exams

亀戸天神社
KAMEIDO TENJIN SHRINE

Located in Tokyo's Shitamachi, once the commonor's residential area in the lower part of the city, Kameido Tenjin Shrine was built in 1646 to honor the 9th century scholar and politician, Sugawara Michizane (845-903, p174). More recently, children and anxious parents have been coming to pray here, hoping for good grades and admission to top universities. Nicknamed the "flower shrine," the gardens with arched moon bridges are famous sights, especially when framed by the purple wisteria (*fuji*) that blooms from mid-April to early May, or chrysanthemums (*kiku*) in November. The *ukiyo-e* master Hiroshige included a print of Kameido Tenjin in his "One Hundred Famous Views of Edo" series (p174). The blossoms are even more lovely at night when they are illuminated after sunset. Check the status of blossom before your visit, since wisteria times may vary.

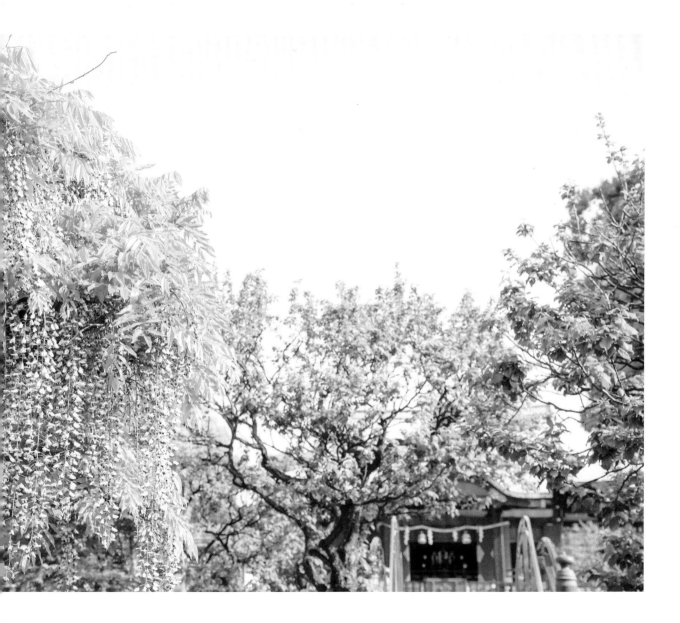

See Noh, Traditional Stories With Dance, Masks and Costumes

Japan is known for its theatrical arts. One traditional performing art is *Noh*, which performs stories from traditional literature through dance using masks and costumes. Since a *Noh* performance is often formal and solemn, *Kyogen* (comic theatre) is performed during intermissions for a few laughs. The National Noh Theatre (Kokuritsu Nohgakudo) opened in Sendagaya in 1983, and is run by the Japan Arts Council. The auditorium seats 627, and the stage is built from 400-year-old cypress trees, the same timber used for some of Japan's shrines. Understanding Japanese is not required, since each seat has a subtitling system, for English or Japanese. On your way to this theater, I recommend stopping by Shinjuku-gyoen, the Japanese garden nearby.

国立能楽堂

NATIONAL NOH THEATRE

Don't Miss the Tunnel of Vermilion Torii Gates and the Colorful Azelea at One of Japan's Most Beautiful Shrines

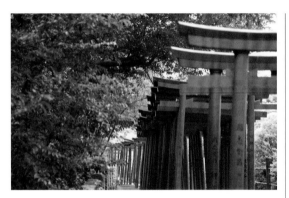

根津神社
NEZU JINJA SHRINE

Legend says that what later became Nezu Jinja Shrine (Nezu Jinja) was founded more than 1,900 years ago by Prince Osu, also known as Yamato Takeru, a legendary prince of the Yamato dynasty. The current Nezu Shrine, rebuilt in 1706, is styled after the Toshogu Shrine in Nikko. This shrine, near Ueno Park, is one of Japan's oldest shrines, and one of its most beautiful. A memorable feature are the vermilion *torii* gates that cover the paths on the hillside above the main shrine, making a tunnel effect. The shrine is best known for its Azalea Festival (*Bunkyo Tsutsuji Matsuri*) held from early April until early May. Azalea bushes bloom in pink, red and white on the hillside garden, and if you would like your photos of the *torii* gates and azalea blossoms without crowds, visit in early morning.

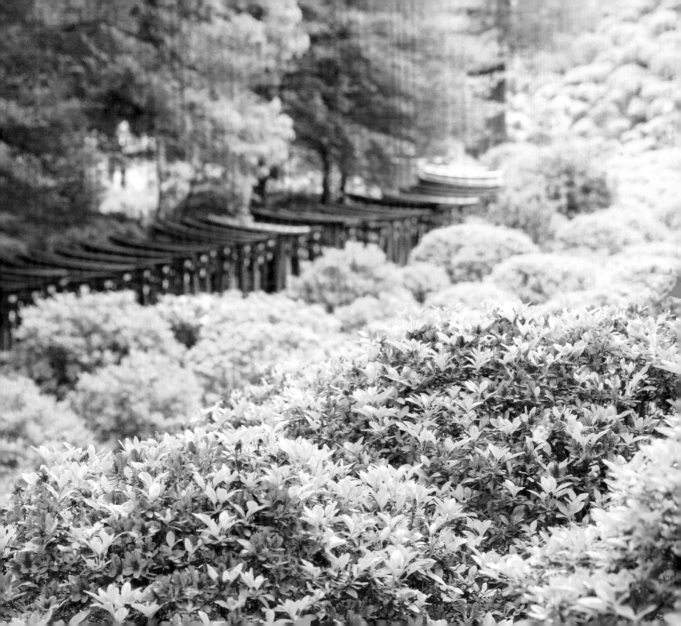

Dedicated to Fudo-Myoo, the Black-Eyed King of Wisdom,
the Temple Was Popular for an Excursion Destination Among
People in the Edo Era

瀧泉寺・
目黒不動尊
MEGURO FUDOSON /
RYUSEN-JI TEMPLE

Ryusen-ji is dedicated to Meguro Fudo-Myoo, the black-eyed immovable King of Wisdom. Built in 808, it flourished during the Edo period under the patronage of the third Tokugawa shogun, Iemitsu (1604-51), and buildings were added in 1634. Meguro Fudoson was popular with pilgrims and as a destination close to Edo. The temple was popular for its *tomikuji* (lottery), and was named one of the three major lotteries of Edo. Every month on the 28th, the temple has *ennichi* (a temple festival) with food stalls and games. It is also famous for *yakuyoke* (warding off evil) so a *hatsumode* (first shrine visit) during the New Year's holiday is a great time to visit.

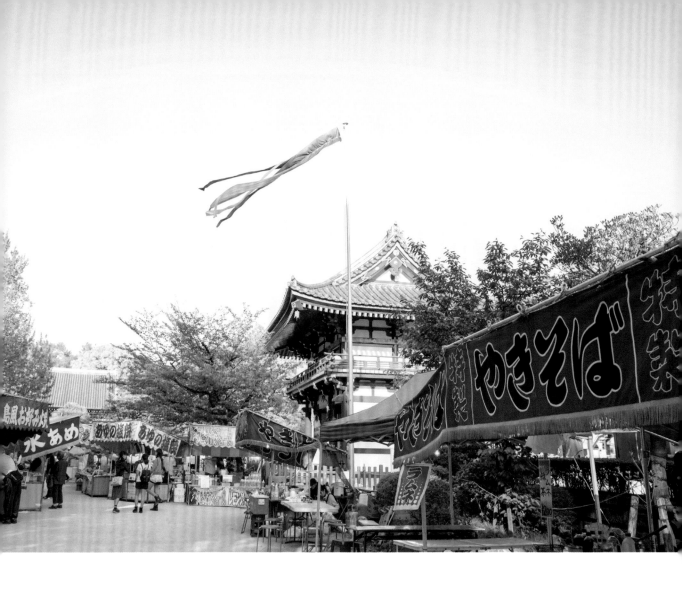

This Huge National Park Has Many Year-Round Activities: a Water Park,
Museums, Children's Forest, Sports, Landscapes, and Flowers

昭和記念公園
SHOWA MEMORIAL PARK

Just 40 minutes from central Tokyo by train, this 445-acre (180 hectare) massive national park has a variety of landscapes and activities, seasonal flowers, a water park, museums, a children's forest, sports facilities and a Japanese garden. Opened in 1983, it was built to commemorate the 50-year reign of late Showa-era Emperor Hirohito. In addition to cherry blossoms, other flowers include rapeseed, tulips, and azalea. Poppies cover the picturesque Flower Hill in the northeast corner. My favorite is "Baby Blue Eyes" (nemophila), tiny blue flowers that bloom in the spring. In the fall, don't miss the beautiful foliage, when a carpet of yellow ginkgo leaves covers the ground. In winter, the park is lit with dreamy winter lights. Rent a bicycle or a boat to paddle in the lake, and explore the park to find the perfect picnic and picture spots!

Join the Crowds to Celebrate Prosperity and Good Fortune at
One of the Three Major Festivals in Japan

The Kanda Festival (*Kanda Matsuri*) is one of Tokyo's biggest, and is held at Kanda Myojin Shrine in mid May during odd-numbered years, alternating with the Sanno Festival in even-numbered years. The festivals began in the early 17th century to celebrate the victory at the Battle of Sekigahara, but have since become a celebration for prosperity and good fortune. Main events are during the weekend closest to May 15th. Saturday is dedicated to parades. On Sunday, the Kanda Festival is about *mikoshi*, portable shrines carried by large teams representing neighborhoods or groups. Over 200 *mikoshi* are carried by teams that take turns carrying their *mikoshi* to the front for a ceremony and prayer. Teams chant as they maneuver their *mikoshi* through the crowds. It's a lot of fun to watch. Don't miss watching the Samurai riding on the streets blocked for the festival.

神田祭

KANDA FESTIVAL /
KANDA MYOJIN SHRINE

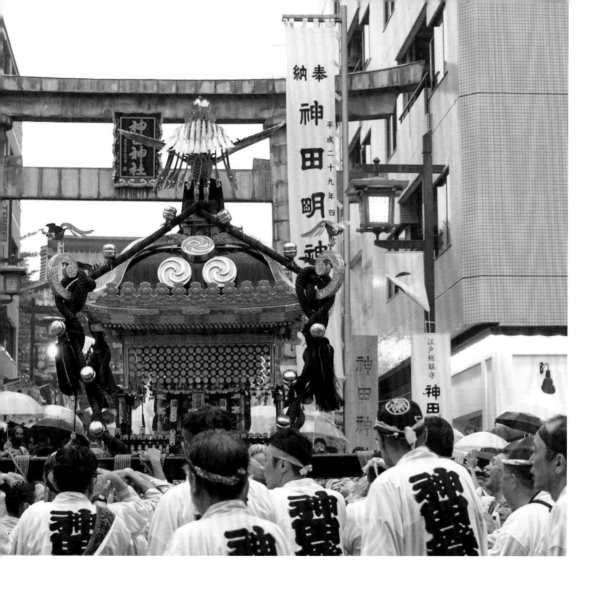

Enjoy a Quiet Garden and a
Collection of Post-1950s Art

Located in a residential area in Shinagawa ward, this former residence of the Hara family was converted into a museum in 1979. The Bauhaus-style building, a rare example of Japanese early modern architecture, was built in 1938. The collection covers post-1950 art movements across several continents and comprises about 1,000 paintings, photographs, sculptures, videos and installations including pieces by Mark Rothko, Yayoi Kusama, Jackson Pollock, Cindy Sherman, Hiroshi Sugimoto, Nam June Paik, Yoshitomo Nara and more. The museum includes a sculpture garden, a shop and the Cafe d'Art, with a glass-walled, light-filled cafe that faces the back garden. The outdoor seating at Hara Museum is one of Tokyo's few quiet spots in the midst of art and green, and is the perfect place to relax with a glass of champagne.

原美術館

HARA MUSEUM OF CONTEMPORARY ART

浅草寺

SENSO-JI TEMPLE / ASAKUSA

The Sensoji Temple, a popular spot for tourists, is dedicated to Asakusa Kannon, the Buddhist god of mercy and happiness. According to legend, two fishermen struck gold and found a statue of the god while fishing on the Sumida River in 628. The first temple was founded in 645, making it the oldest temple in Tokyo. Enter through the Kaminarimon (Thunder Gate), the symbol of Asakusa. Walk along Nakamise, a street full of shops, to the temple's second gate, the Hozomon. The street dates back to the 17th century and most shops have been run by the same families for generations. Along with typical Japanese souvenirs such as *yukata* and *sensu* (folding fans), local snacks from the Asakusa area are sold here. Seasonal events are held on the temple grounds, including Asakusa-jinja Shrine's Sanja Festival in May, the *hozuki* (Chinese lantern plant) market in July and the photogenic *hagoita* decorative paddle market in December.

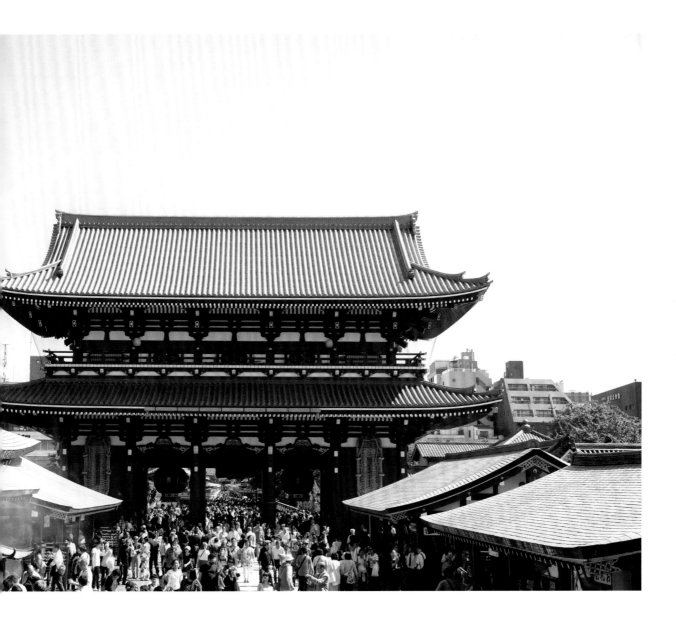

Enjoy One of Tokyo's Largest Parks,
With a Bird Sanctuary, Hiking Trails
and a Beach

葛西臨海公園

KASAI RINKAI PARK

Opened in 1989, Kasai Rinkai Park is near Tokyo Bay between the Arakawa River and Tokyo Disneyland in Edogawa ward. One of the largest parks in Tokyo at 200 acres (81 hectares), it was built to preserve Tokyo Bay's natural environment. The park includes Tokyo Sea Life Park (an aquarium), Sea Bird Sanctuary, hiking trails, barbecue areas, and beach access to Kasai Beach Park. It's a great place to have a picnic, pitch a tent, go fishing, barbecue with friends, cycle, and hike. If the views from the observatory aren't enough, a ride on the Diamond and Flowers Ferris Wheel (384 feet tall) provides views of Tokyo Disneyland, Rainbow Bridge, and the Bousou Peninsula of Chiba Prefecture, and, on a clear day, Mount Fuji. In the spring, you can also pick as many poppies and *yagurumagiku* (cornflowers) as you like!

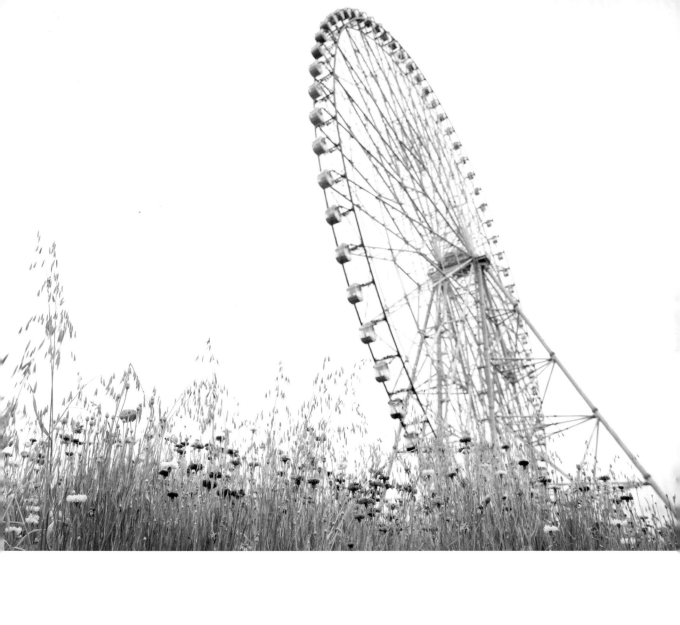

SUMMER

natsu

How About a Gourmet Coffee After Enjoying a Tranquil Japanese Garden From the Meiji Period?

清澄庭園
KIYOSUMI GARDENS

Kiyosumi Gardens (Kiyosumi Teien) is a traditional Japanese garden in Fukagawa. In 1878, the founder of Mitsubishi Corporation, Iwasaki Yataro, bought the land and rebuilt the garden for the enjoyment of his employees and to entertain guests. Opened in 1880, the garden is in the style of the Meiji Period, a circuit style with a pond fountain, small hills, and *karesansui* (a dry landscape). It is famous for *isowatari* (stepping-stone paths), with stones placed in a pond to form a walkway, and where the view of the landscape depends on your position. Hills and waterless waterfalls were constructed with 55 water-worn boulders from all over Japan. It's a peaceful place to spend an afternoon. Aside from the garden, the Fukagawa Edo Museum is only a five-minute walk away. You can enjoy a cup of coffee in the area, too—there are many hip coffee roasters.

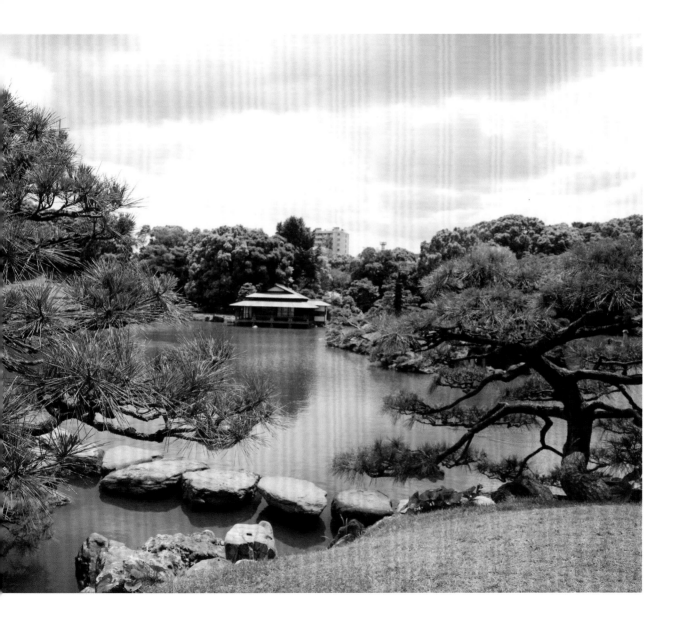

One of Tokyo's Most Exciting Entertainment Areas Features an Observation Deck With 360 Views

Opened in 2003, Roppongi Hills sits on a 27-acre site and includes offices (many IT companies), shops, restaurants, residences, an art museum, a hotel, a Japanese garden and a movie theater complex. It is the centerpiece of the famously foreigner-friendly Roppongi area. The Tokyo City View, one of Tokyo's most famous observation decks, is on the 52nd floor of Mori Tower and offers a 360-degree view of Tokyo, and if you are lucky you will see Mt. Fuji. Mori Art Museum, the highest museum in Japan, is on the 53rd floor of the tower, and hosts innovative exhibitions. Mori Art Museum together with the National Art Center and Tokyo Midtown's Suntory Museum of Art are known as the "Art Triangle Roppongi." The Mohri Garden is a green oasis between the buildings, in the style of a traditional landscape garden. Visitors love to come here to take a walk and have lunch.

六本木ヒルズ
ROPPONGI HILLS

Experience Kabuki, a Traditional Japanese Entertainment for the Commoners from the 1600s

*K*abuki flourished during the Edo period, and dates back to the 1600s, when Shakespeare's *Hamlet* and *Othello* were first performed in London. The theater has been rebuilt several times since the original of 1889. The most recent version, completed in 2013, added a 29-story tower, while preserving its Momoyama-style facade influenced by 16th-century castle architecture. Since *Kabuki* was entertainment for commoners in feudal Japan, plots are easy to follow, with love, duty, and revenge popular themes. You can rent an English-language earphone, and each program usually has three shows. If you don't have time to watch all three *Makumi*, you can watch one show from the upper gallery on the fourth floor with same-day tickets. Don't miss the costumes and props in the Kabukiza Gallery on the fifth floor, and you can shop for *Kabuki* items and a lunch box *(bento)* at the souvenir shops underground.

歌舞伎座
KABUKI-ZA

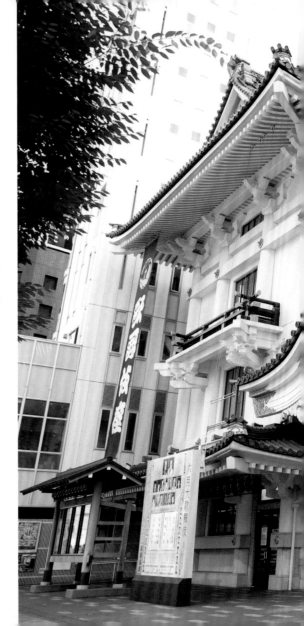

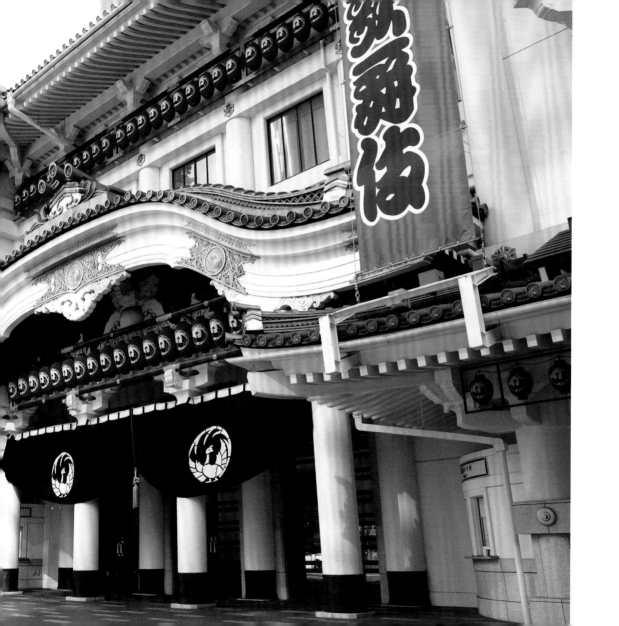

Starting Point of Japan's Railway Network, This Huge Station
Has Shops, Dining, Galleries, and More

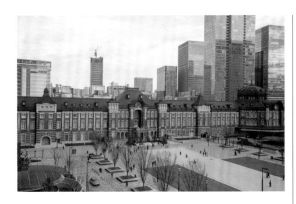

東京駅
TOKYO STATION

Travelers can get just about anywhere in Japan from Tokyo Station. In 2012, a hundred years after completion, the nostalgic red brick building was restored. Located between the Imperial Palace and the station building, Marunouchi is one of Japan's most prestigious business districts. Shopping and dining complexes have recently opened in skyscrapers like Marubiru (Marunouchi Building) and Kitte. Beneath the station are dozens of underground passages, shopping streets, dining areas, galleries and more. Foodies will want to check out Ramen Street, Kitchen Street and countless *bento* (lunch box) stores. Tokyo Character Street features more than 20 stores each themed after a well-known popular *anime* character, including those from Dragon Ball, Naruto and One Piece, as well as Snoopy, Pokémon and Hello Kitty. The station is huge, so don't get lost!

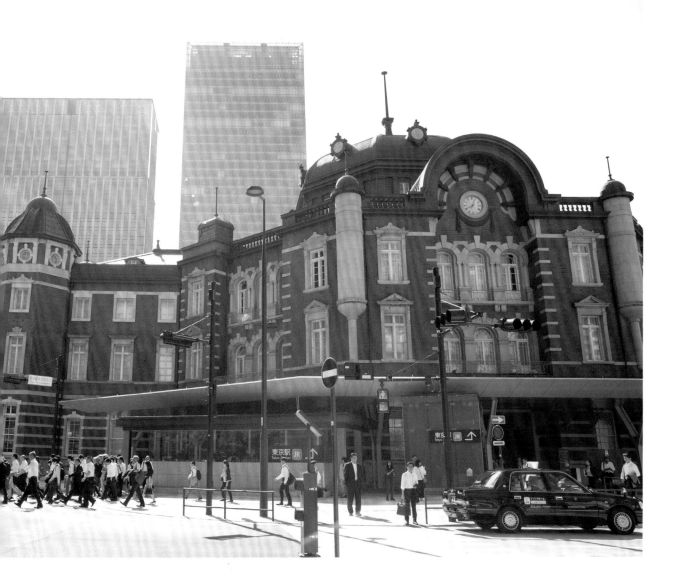

Enjoy a Visit to This Walkable Island, Tokyo's Little Known "City of Art"

天王洲アイル
TENNOZU ISLE

Tennozu Isle was first a fort that protected Shinagawa from attacks from the sea in the Edo period, but later was used as warehouses. The small, walkable island is a stop on the Tokyo Monorail that goes to Haneda Airport. Street murals can be seen on Bond Street. Archi Depot is an architectural model museum with original scale models of completed buildings and competition pieces by many well-known architects. Pigment is a shop-museum-atelier devoted to color and art tools, and was designed by architect, Kuma Kengo. Located in the active warehouse just across the bridge from the island, Terrada Art Complex houses five small galleries, each hosting temporary exhibits. Spend a fun day in Tennozu Isle gallery and cafe hopping, and enjoy the sea breeze with a craft beer on the terrace of T.Y. Harbor.

Enjoy the Trails and Flowers in This Circuit-Style Historical Garden With a Modern Tokyo Backdrop

小石川後楽園

KOISHIKAWA KORAKUEN GARDENS

Koishikawa Korakuen dates back to 1629 in the Edo Period (1600-1867), and was part of the Tokyo residence of the Mito branch of the ruling Tokugawa family. The name "Korakuen" comes from a poem that says that the people's happiness should come before the ruler's. The garden, designed in the circuit-style, has a central pond surrounded by walking trails, and a stone stairway that is like a secret labyrinth. Influenced by a Chinese scholar, the garden features scenes that represent famous Japanese and Chinese landscapes, including a reproduction of Seiko Lake (China), a full moon bridge and others. In the spring, the azaleas, wisterias, lotus, iris and the weeping cherry blossoms are magnificent. The garden is located in the middle of Tokyo and right next to Tokyo Dome City, an amusement park and large event venue.

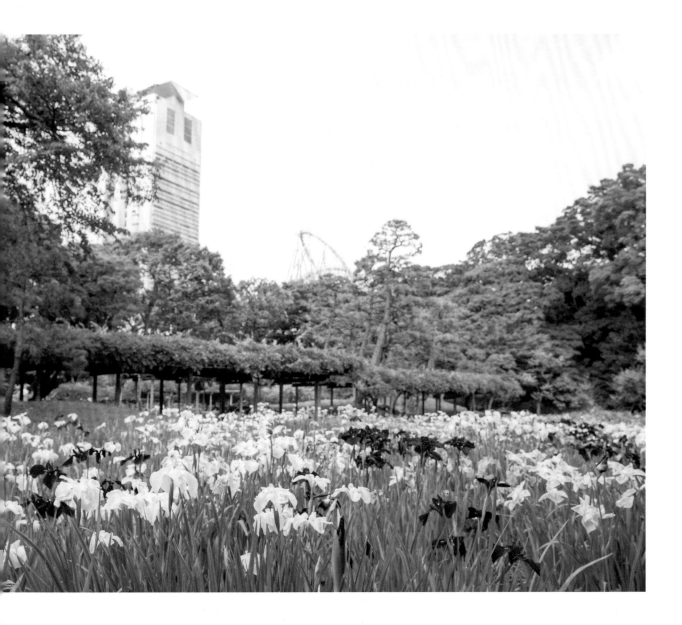

It's Famous for the Hydrangeas, but All Four Seasons are Beautiful

Meigetsu-in Temple was founded in 1160 by the Rinzai sect of Zen in Kita-Kamakura. The tomb of Hojo Tokiyori, a leader of the Kamakura shogunate in the 13th century and one of Kamakura's founding fathers, is found here. Kamakura's not-so-well-kept secret is that it is also known as Ajisaidera (Hydrangea Temple). Although the temple is packed with tourists flocking in to see its more than 2,500 hydrangea bushes during the rainy season in June when it turns into a blue-flowered paradise, all four seasons can be enjoyed here. Don't miss the fall foliage when the stunning scenery can be seen from the circular full moon window in the Main Hall. It's your choice when you visit; each season is beautiful. From Tokyo, Kita-Kamakura Station it's about a 50-minute ride on the Yokosuka Line.

あじさい寺 / 明月院
MEIGETSU-IN TEMPLE / KITA-KAMAKURA

Watch Out for "Flying" Penguins Against Tokyo's Cityscape—Then Go See the Jellyfish Tunnel

サンシャイン
水族館

SUNSHINE AQUARIUM

Sunshine Aquarium is on the rooftop of the nine-story World Import Mart Building near Ikebukuro Station, and was built as an "oasis in the sky" in the heart of the metropolis. The tropical resort atmosphere and futuristic design give the aquarium concept a unique, modern twist. More than 80 tanks are home to 37,000 fish representing 750 species. Take a stroll under a giant water tank and spot penguins overhead, with Tokyo's cityscape as the backdrop—a breathtaking view you won't find anywhere else. Other favorite spots here include the deep blue Jellyfish Tunnel and the Sunshine Lagoon, a huge tank with a wide variety of fish. The exhibits make use of a QR translator. Just scan the QR codes, and you'll have English information. My secret is to visit the aquarium on weekday mornings.

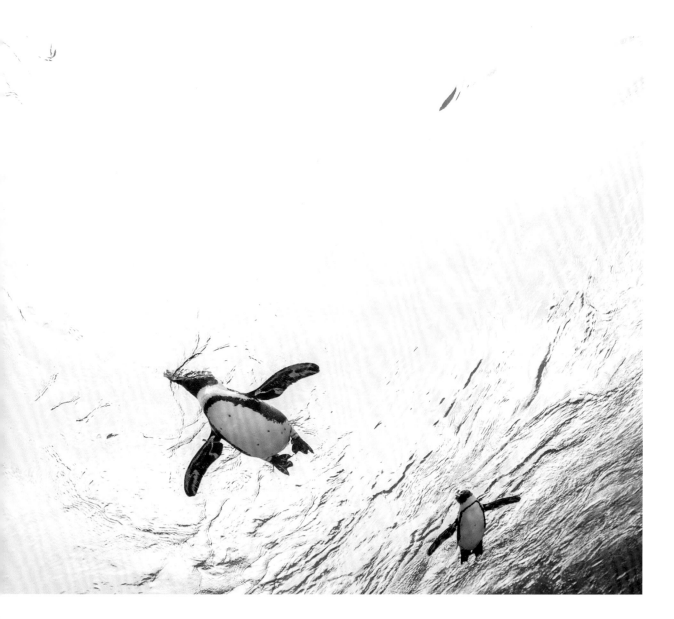

Catch the Big Boys in Action at
Japan's Largest Sumo Stadium

*S*umo, the national sport that dates back over 1,500 years, can be seen here three times a year—15 days in January, May and September. Bouts are short and tense, and crowds respond by throwing their cushions in the air. Afterwards, join the fans as the supersize wrestlers leave the stadium in their *yukata* (cotton robes) and *geta* (wooden shoes). Don't leave without trying a wrestler's traditional dish of *chanko-nabe*, an enormous hot-pot filled with seafood, meat, dumplings and vegetables. Many *Chanko-nabe* restaurants nearby are run by retired wrestlers. The Edo-Tokyo Museum next door displays an interactive journey into Tokyo's past, to the present and future. This is one of the country's top museums, with over 2,500 items from traditional toilets to transport. The Sumida Hokusai Museum dedicated to the *ukiyo*-e artist Hokusai is also a 10-minute walk from the Kokugikan.

両国国技館

RYOGOKU KOKUGIKAN

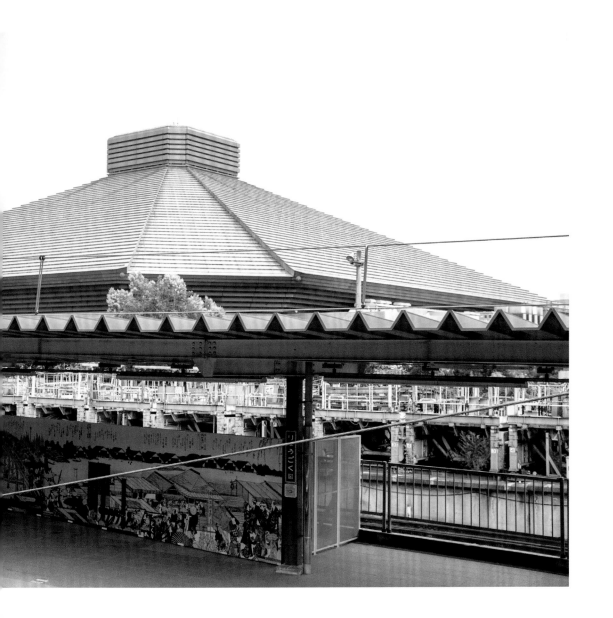

Pray for Love at This Shrine for
Those Hoping for a Good Marriage

This shrine is known as the place to pray for a good marriage. During the Edo Period (1603-1867) every Japanese wanted to go on a "Blessing Pilgrimage" to the Grand Shrine of Ise in the Mie prefecture of Japan. In 1880, the Imperial family approved another site in Hibiya, Tokyo, so that worshippers wouldn't have to travel to Ise. In 1900, Emperor Taisho married Empress Teimei in a Shinto ceremony in the Imperial Shinto Shrine. Hibiya Daijingu later performed a Shinto wedding ceremony there. Ever since, the shrine was the place to pray for finding a spouse or ensuring a successful marriage. Young women come to pray or buy an *omamori* (lucky charm), hoping to improve their fortunes in love. From June 1 to July 7, the bamboo trees are hung with wishes written on paper during the Tanabata Prayer Festival (Star Festival).

七夕祭・
東京大神宮

TANABATA FESTIVAL /
TOKYO DAIJINGU SHRINE

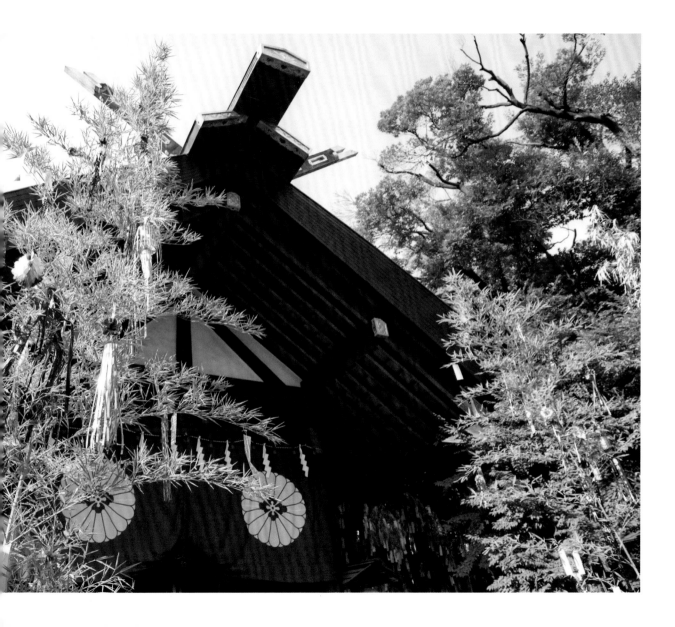

Get Up Early to See the Beautiful Morning Glories and Enjoy the Shops and Food Stands

The morning glory, *asagao* (literally "morning face"), came from China in the Nara period. Gardeners in Iriya began growing them, and they became a favorite among the locals in the Edo period. The festival at Iriya Kishimojin began in the Meiji period (1868-1912), was discontinued in 1913 but revived in 1948. The three-day festival attracts 400,000 visitors each year from July 6 to 8. The market was originally near Iriya Kishimojin (Shingen-ji Temple), where people worship a guardian of childbirth and children's growth, and it is part of the temple festival. In addition to the 60 flower shops, more than 80 food stands (*yatai*) line the street. The market opens at 6 a.m. and closes at 9:30 p.m. The food stands are busiest in the evening, but to see the morning glories in full bloom, arrive early. It's a great way to get a taste of Japanese summer!

入谷朝顔まつり・入谷鬼子母神

IRIYA ASAGAO FESTIVAL / IRIYA KISHIMOJIN TEMPLE

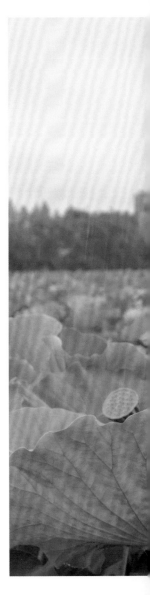

This Gigantic Park Has a Temple, Museums, a Zoo, and Lotus Blossoms on the Pond in the Summer

上野恩賜公園
UENO PARK

Ueno Park was originally part of the Kaneiji Temple, one of Tokyo's largest. After the Meiji Restoration in 1868, Kaneiji was nearly destroyed, but the temple grounds were converted into a park and opened to the public in 1873. The grounds include the Tokyo Metropolitan Art Museum, the National Museum of Western Art, the National Museum of Nature and Science, Ueno Zoo and more. In the summer, the pond, Shinobazu-no-Ike, becomes a magical sight when thousands of lotus blossoms, long associated with purity, rebirth, and divinity in Japan, create a sacred air. Near the park you can explore the vibrant market street, Ameya Yokocho, also called Ameyoko, originally a black market after World War II. From groceries to drug stores to boutiques, everything can be found here. If you love sweets, try *anmitsu* (Japanese traditional sweet) at Mihashi nearby.

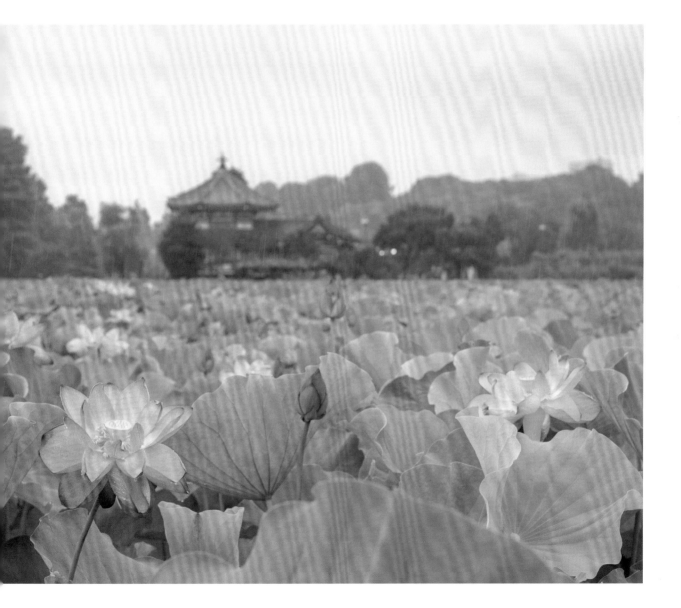

Enjoy This Popular Beach and Surfers' Paradise and Enoshima Island Walk

Just over an hour from Shinjuku, Kugenuma Beach, in the Shonan coastal area, is a popular and easy to access beach near Tokyo. Known as the birthplace of surfing in Japan, it is often crowded with surfers. Since it is only a 10-minute walk from the station, many arrive by train and rent surfboards nearby. The beach has a lot to offer: more than ten beach volleyball courts, a grassy BBQ area, *umi no ie* (beach houses) offering food, drinks, rentals, locker rooms, showers, and more. You can enjoy local foods like *kakigori* (shaved ice), *ramen*, or *yakisoba*. If you're lucky, you'll see an astounding view of Mt. Fuji, with the sun going down just next to it. It is really magical and romantic. Near Kugenuma, Enoshima offers everything—parks, shrines, aquariums, local restaurants and even caves. Don't forget to order famous *kama-age shirasu* (freshly boiled baby sardines) at a restaurant. Enjoy Japan's summer beach!

鵠沼海岸・江ノ島
KUGENUMA BEACH & ENOSHIMA ISLAND

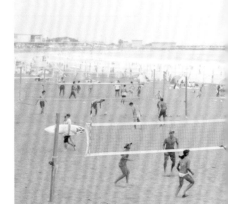

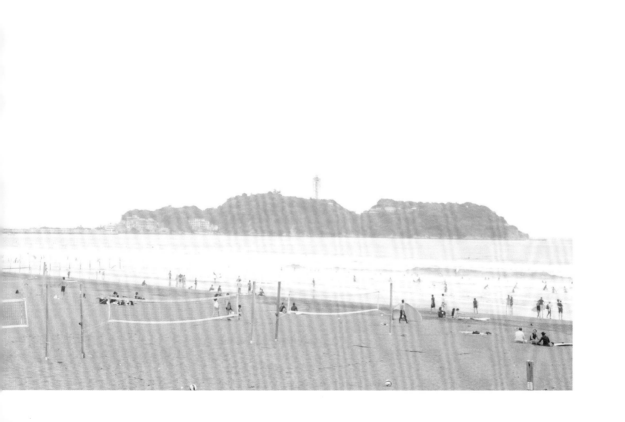

Don't Miss This Popular Unique Cruise to See the Illuminated Factory Landscape

You can head out of Tokyo down to harbor cities Kawasaki and Yokohama for cruises that will take you to another world. Not your typical romantic journey, the Night Factory Cruise gives visitors some unexpected insight into industrial areas. The lit up factories look like the fortress of the Space Station. The 90-minute cruise departs from 4:30 p.m. in December to 7 p.m. in June. The first stop is outside Minato Mirai port so you can look back at the sunset over Yokohama. Passing Rainbow Bridge, the cruise enters the Keihin Industrial Area through canals, as glittering factory lights continue for about 80 minutes. In total, the boat stops about seven or eight times for photos. These tours are especially recommended for photographers looking to capture beauty in unexpected environments. Make your reservation soon, because the cruises are so popular they are booked months in advance.

京浜工業地帯
NIGHT FACTORY CRUISE
/ KEIHIN INDUSTRIAL ZONE

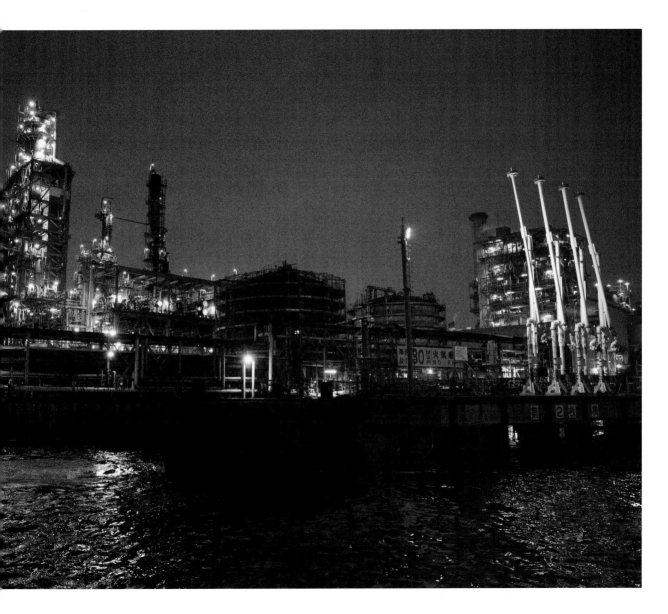

Amazing! See the High-Style
Goldfish Show and the Jellyfish
Kaleidoscope Tunnel

Japan, surrounded by the sea, has over a hundred aquariums—each with its own unique appeal. Sumida Aquarium is a stylish and trendy one, located on the 5th and 6th floors of Tokyo Skytree Town in the Asakusa area. First, visitors will get drawn into the jellyfish kaleidoscope tunnel, which is oddly soothing as you watch their translucent bodies illuminated by blacklight. Don't miss the indoor penguin zone and a huge tank that replicates the sea of the Ogasawara Islands, Tokyo's tropical islands. In summer, the aquarium's Edorium area becomes "Tokyo Goldfish Wonderland," a living art exhibit celebrating the role of goldfish in Japanese summer festivals. Based on the ancient cultural traditions of the Edo period, the Edorium area is decorated with goldfish lanterns and *furin* (bell-shaped wind chimes). You will be amazed by the almost 1,000 goldfish from 20 different species that are on display.

すみだ水族館

TOKYO KINGYO WONDERLAND /
SUMIDA AQUARIUM

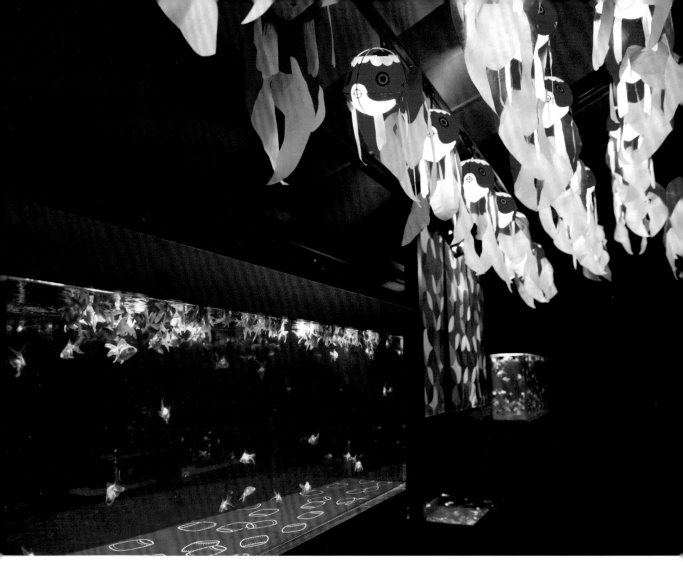

Experience This Secret Oasis of Nature, Like a Jungle in the City

This ravine is a surprisingly wild environment in the midst of Tokyo's popular residential district, Setagaya. The atmosphere offers a very different experience of nature from the usual manicured parks and Zen gardens. The gorge's jungle-like canopy is home to birds and small creatures. The only valley in the city, it includes a little over a half mile (1 km) walking trail along the Yazawa River. As you descend into the ravine, you'll notice that the air becomes cooler. Interesting spots along the trail include a Japanese garden, remains of tunnel tombs, small shrines, and a tea house. At the other end of the valley stands Todoroki Fudo, an atmospheric temple. The path is frequented by students and workers, as well as joggers and retirees in walking groups, but on a midweek early morning and afternoon it is serene and peaceful.

等々力
渓谷
TODOROKI
VALLEY

渋谷 スクランブル交差点

SHIBUYA CROSSING

The Shibuya Scramble, an intersection of seven crossroads, is in front of the Hachiko exit of the JR Shibuya Station. The intersection sees hundreds, even thousands of people crossing at any one time, and can be seen in films like *Lost in Translation* and *The Fast and the Furious: Tokyo Drift*, and has appeared in music videos, newscasts, and animated films. Tourists love to take videos here too. Video screens flash above each corner as businessmen, students, tourists, and shoppers wait and cross in concert. Go at dusk, one of the scramble's peak times, or walk across to experience it for yourself, or watch from above. The second floor of the Starbucks in Q-Front building and the L'Occitane cafe nearby have good views. A secret for aspiring Scramble watchers: go to restaurants high up on the Shibuya Excel Hotel Tokyu's 25th floor.

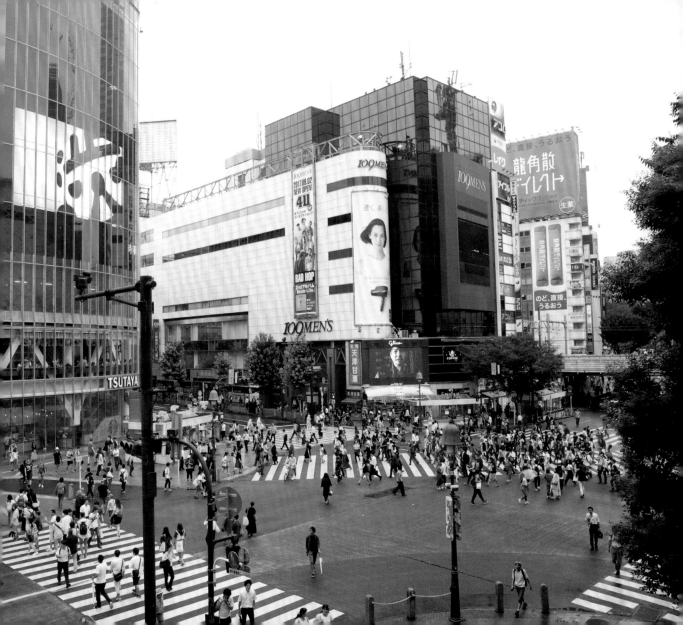

Visit an Artist's Home, Known for His Abstract Art and Surrealism

The museum is the former residence and studio of modern artist, Okamoto Taro (1911-1996) who worked in both Abstraction and Surrealism. His best-known work is a huge tower—the *Tower of the Sun*, created for the 1970 Expo in Osaka. The building blends in with the surrounding residences, but inside, you will see the artist's distinctive figure sculptures and chairs in the garden. The studio has artwork left in place and reflects the world of the artist. Another famous piece, a colorful 98-foot (30-meter) long painting of 14 panels, *Myth of Tomorrow* was shown near the Keio Inokashira line in the Shibuya station. The mural depicts the atomic bombings of Hiroshima and Nagasaki in 1945. The painting was commissioned for a hotel in Mexico City in 1968, but the hotel was never finished and the mural was never displayed there.

岡本太郎記念館
TARO OKAMOTO MEMORIAL MUSEUM

Come See the Goldfish and Colored Lights, Stay for the DJ and Cocktails

From its beginning in 2011 to celebrate the 100th anniversary of the bridge at Nihonbashi, Eco Edo Art Aquarium has become a popular summer event in Tokyo (July-September). The exhibition is a collaboration of modern technology and themes of Japanese traditional culture, displaying over 8,000 goldfish, LED lights, projection mapping and art installations. It's stylish for the local women to wear *yakuta* (summer *kimonos*) with *uchiwa* (Japanese fans) as they walk around. It's the most current and artistic aquarium so far. Thousands of goldfish swim in various shaped fish tanks with colorful lights and effects. Go after 7 p.m. At night, the Art Aquarium turns in to the coolest club venue in Tokyo. You can enjoy live performances including live DJs, bands and cocktails. If you visit Tokyo in summer, don't miss it!

日本橋
アートアクアリウム

ECO EDO ART AQUARIUM / NIHONBASHI

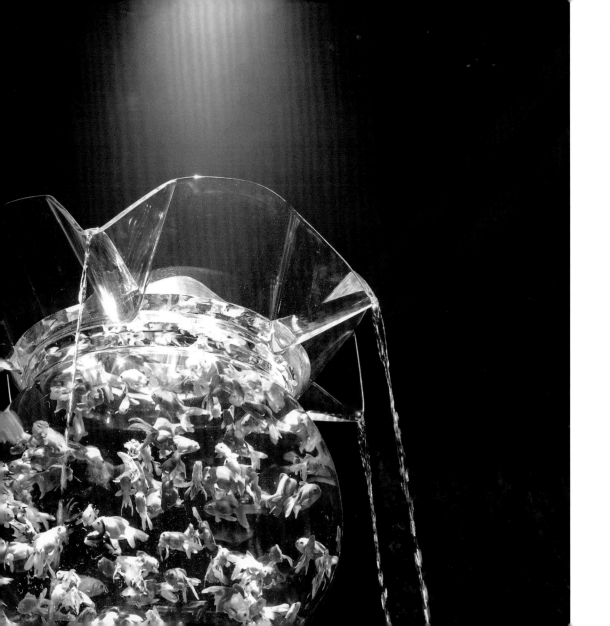

FALL

秋

aki

Come See This Flower Garden From the
Edo Period Inspired by Literature and Poetry

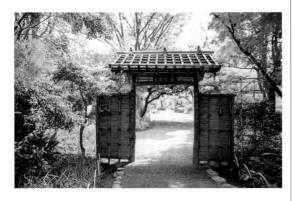

This small garden in the Sumida ward was created by a merchant along with artists and cultural figures between 1804 and 1830 (Edo period). When it opened, it had 360 plum trees. Over the years, flowers and plants mentioned in classic Chinese and Japanese literature and poetry were added. References to Japan's literary world are memorialized in 29 stone monuments, including poetry engravings from authors like Matsuo Basho, and calligraphy inscriptions from esteemed Japanese poets. One of the gardens' proudest features is its Bush Clover Tunnel (the Tunnel of Hagi), in peak bloom around September, which envelopes visitors in lush greenery and pale pink blooms. While autumn is the best time to see Mukojima Hyakkaen, a variety of flowers, trees and herbs bloom all year. The name Hyakkaen means "garden of a hundred blooms."

向島百花園
MUKOJIMA HYAKKAEN GARDENS

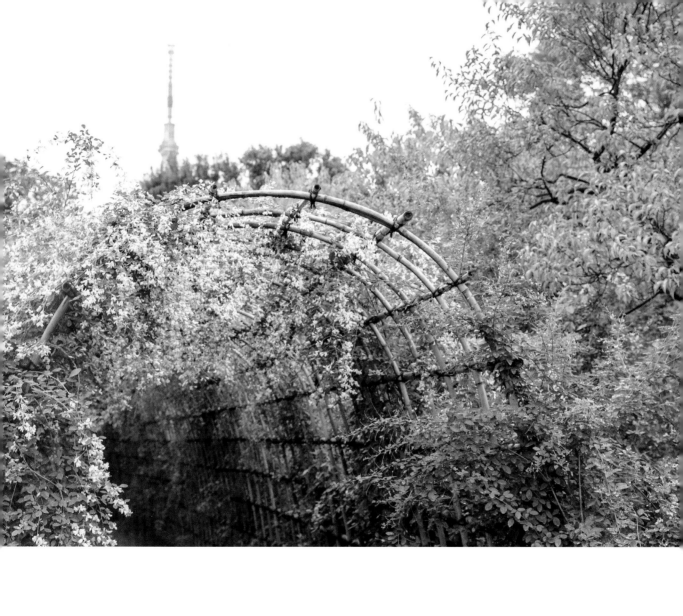

See Japan's Most Lavish and Colorful Shrines, Covered in Carvings, Gold Leaf and Fanciful Characters

日光東照宮
NIKKO TOSHOGU SHRINE

Located in Tochigi prefecture—about two hours by train from Tokyo, Nikko Toshogu Shrine is the resting place of the founder of the Tokugawa shogunate, Tokugawa Ieyasu. Built in 1617-1636 and now a UNESCO World Heritage site, you will find more than a dozen colorful, elaborate buildings in this lush forest. Look for wood carvings that decorate the storehouses, and you'll see sculptures by Hidari Jingoro, *Sanzaru* (the three wise monkeys—see no evil, hear no evil, speak no evil) and *Nemurineko* (the sleeping cat) that are popular images in Japan. At the entrance, Yomei-mon Gate is Japan's most lavishly decorated gate and was opened to the public in 2017 after 44 years of restoration. The gate is covered with 508 detailed carvings of children and elders and mythical beasts and is a masterpiece of Edo-period craftsmanship. Festivals are held here in the spring and fall.

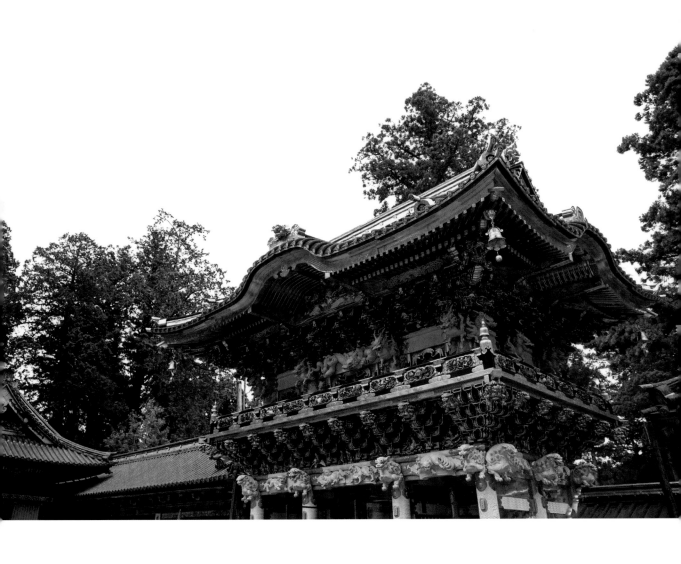

Come to This Hip, Fun Park to Take Photos, Enjoy Street Entertainment, and Look For Elvis

Formerly a parade ground and barracks for the U.S. military, this was also the site of the 1964 Tokyo Olympics. Today, the park features water fountains, an athletic field and an outdoor stage. During the main flower-viewing (*hanami*) weekend, the park turns into one huge party! In the summer, people relax under the trees. In autumn, the park explodes with color—bright yellow ginkgo leaves and deep red maple trees. It's a good place to take portraits because roses bloom twice a year, spring and autumn, and for dog lovers, there is a dog run. Part of Yoyogi's charm is that it attracts all sorts of people. Street entertainment (mostly on weekends) can be found in front of Harajuku gate, at the eastern end of the park. The most popular event is the Elvis Dance, when Japanese Elvis impersonators show off their moves.

代々木公園
YOYOGI PARK

Don't Miss This Stunning Museum Full of Pre-Modern
Japanese and East Asian Art, With a "Secret" Garden

根津美術館

NEZU MUSEUM

Walk along the covered outdoor path with bamboo-clad walls and enter into beautiful double-height interiors with glass walls. This 43,000-square-foot space was redesigned by Kuma Kengo in 2009 to house the private collection of Nezu Kaichiro, the president of Japan's Tobu Railway. After his death, his son preserved the collection—pre-modern Japanese and East Asian art, from calligraphy to sculptures to ceramics—and turned his father's residence into this museum that includes over 7,400 pieces. Famous items include Edo period folding screens, *Irises (Kakitsubata)*, by Ogata Korin on display from the middle of April through early May. Visitors love the gardens and stone pathway through lush, hilly grounds with Buddhist statues and teahouses alongside tranquil ponds. They call it a "secret" garden, but don't blame me for telling you about it.

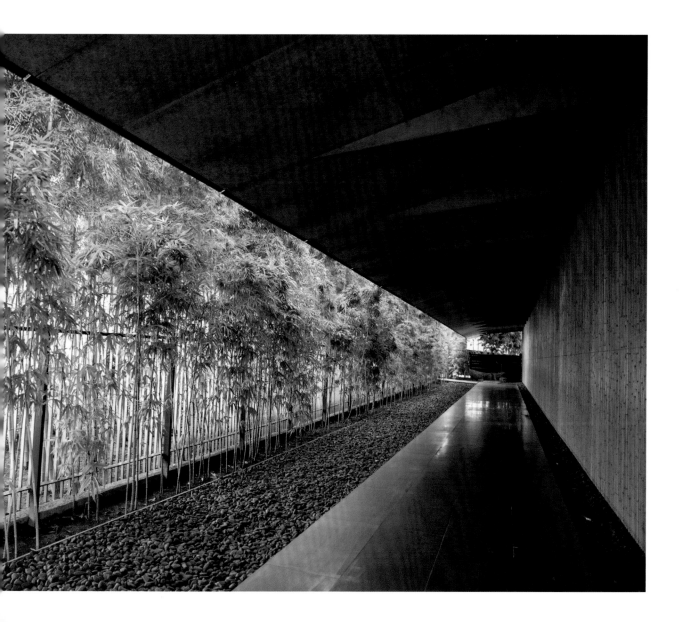

Enjoy Afternoon Tea and a Romantic and Sentimental Stroll at
the Most Gorgeous Japanese Garden in Tokyo

椿山荘
CHINZANSO

This garden is on the grounds of the five-star Chinzanso Hotel in Bunkyo ward, but is open to the public. Planted with seasonal flowers and trees, it is beautiful year round. Many historical monuments and statues from all over Japan, like the 16-century, three-story pagoda from Hiroshima, remain from when the property was owned by Prime Minister Aritomo Yamagata in the late 1800s, and later by Baron Heitaro Fujita. In the spring, enjoy the cherry blossoms, in autumn, see the rich colors of the maple leaves, in winter, see the famous flowering *tsubaki* (camellia). The name Chinzanso means "villa on a mountain of camellias." From late May to early July, see the magical sight of thousands of fireflies. Fireflies (*hotaru*) have been known as an important symbol for the beauty of summer in Japan for more than 1,000 years.

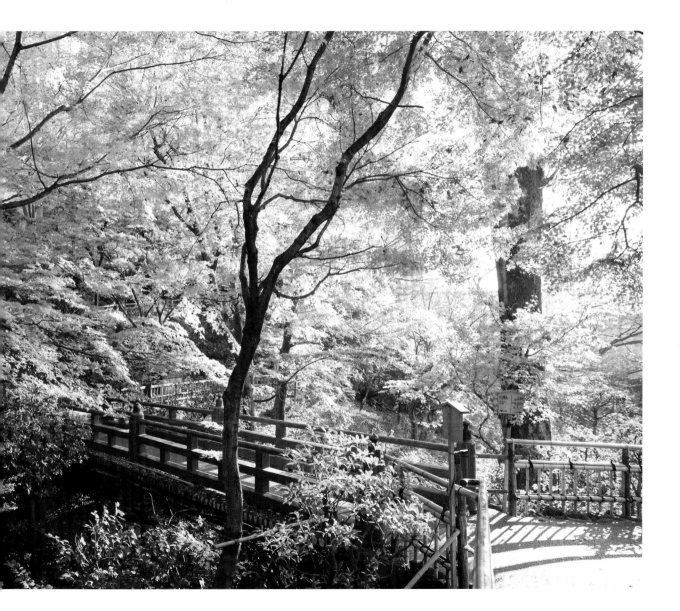

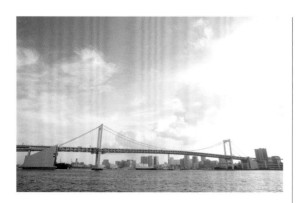

レインボーブリッジ ＆お台場

RAINBOW BRIDGE & ODAIBA

Odaiba is a group of small man-made fort islands (*daiba* means "fort") built at the end of the Edo Period to protect Tokyo against attacks from the sea by U.S. "Black Ships" (warships). More than a century later, after adding massive landfill, Odaiba has become one of Tokyo's most popular tourist attractions with shopping, dining, Odaiba Seaside Park, the Statue of Liberty and a beach. Linking mainland Tokyo with Odaiba, the Rainbow Bridge, completed in 1993, changes color for special occasions, with rainbow colors appearing during the holiday season. A little-known fact about the Rainbow Bridge is that you can walk across it! The best way to enjoy the views without the wind and noise may be by sitting in the front seats in the first car of the *Yurikamome* train. Don't miss the lit up *yakata-fune* (houseboats) that look like jewels floating along.

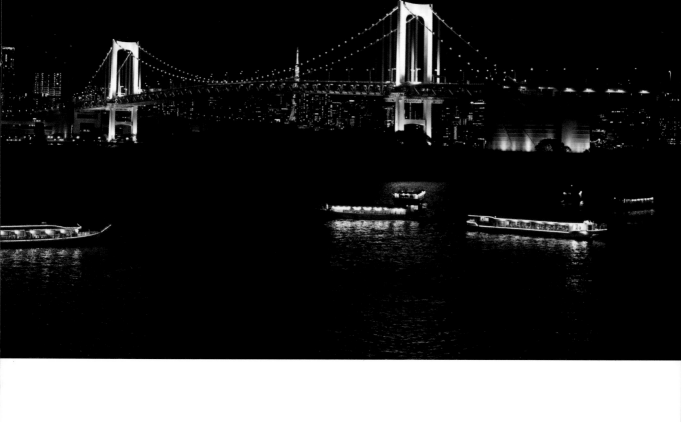

Visit This Serene Shrine Surrounded by 100,000 Trees From All Over Japan

明治神宮
MEIJI JINGU SHRINE

The shrine was built in dedication to Emperor Meiji and Empress Shoken in 1920. At the entrance near Harajuku station stands a 40-foot-high (12-meter) *torii* gate made of 1,500-year-old cypress. Visitors are surprised when they hear that the huge surrounding forest was artificially created. All 100,000 trees were donated from across Japan and were carefully planned to form an eternal forest. On Sunday mornings you might see a traditional wedding procession (or two) in the courtyard—the bride in a white *kimono* and hood, and the groom in his formal black robe, walking under a big red parasol, with Shinto priests leading followed by the wedding party. As one of Japan's most popular shrines, in the first days of the New Year, more than three million visitors come here for the year's first prayers (*hatsumode*).

Take a Walk, Rent a Rowboat, Go to the Zoo, and Visit the Ghibli Museum, the Place for Animation Movies

This park is in the artistic, trendy neighborhood of Kichijoji, and is one of Tokyo's greenest and most picturesque. You can rent a rowboat on Inokashira Pond, one of the most popular places to see cherry blossoms in Tokyo. The park includes a zoo, a museum, a shrine, and food options. The bright red Benten Shrine contrasts with the green of the trees. Near the shrine you'll find a small spring, *Ochanomizu* where shogun Tokugawa Ieyasu drew water for his tea ceremonies. You can visit Studio Ghibli, famous for the animation movies by Hayao Miyazaki, (*Princess Mononoke* and *Spirited Away*). Visitors book far ahead to see the museum, so check the website before you go. Then explore the little-known area of Kichijoji, regularly voted as the best place to live in Tokyo. It offers shopping, good food, a traditional location, and green spaces wrapped up in a perfect package.

井の頭
恩賜公園
INOGASHIRA PARK

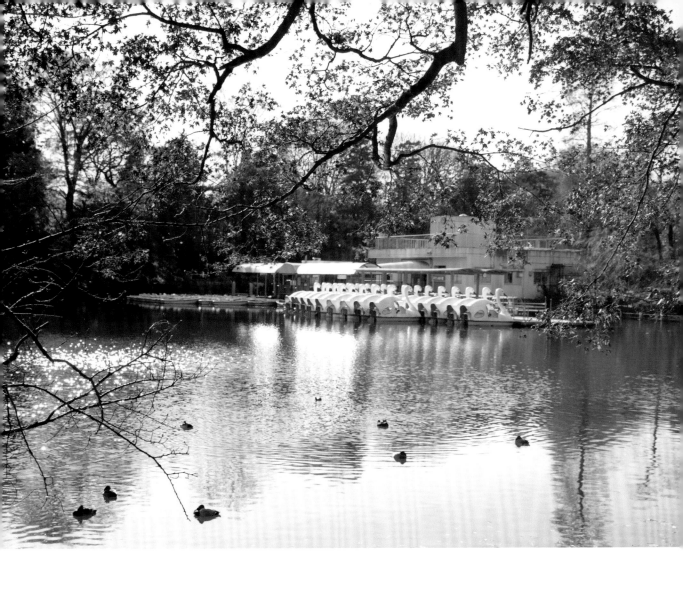

Have Fun and Learn About Culture Through This Park's Events and Festivals

日比谷公園
HIBIYA PARK

Opened in 1903, Hibiya Park is Japan's first modern, Western-style public park built on the grounds of a feudal lord's residence from the Edo period. Just a 10-minute walk from the Ginza, this 40-acre public park is known for its fountains, flower gardens, tennis courts, library, restaurants, concerts, and more. The park is also an oasis for business people, as it adjoins the Ginza and the Kasumigaseki business districts. At lunchtime lots of office workers eat their *bento* (lunch boxes) on the park benches. The park also hosts unique events throughout the year. You can learn about Japanese culture, as well as enjoy favorites of other cultures at events such as the African Festival (June), a Summer Oktoberfest (July), an annual chrysanthemum exhibit (November) and a Christmas market (December). If you are hungry, try *hayashi rice* (a dish of rice with hashed beef) at Matsumotoro in the park, the classic *yoshoku* (western dishes) restaurant.

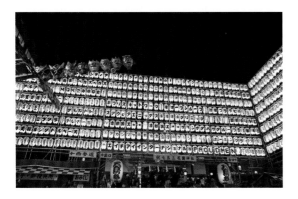

Pray to the God of Business and Prosperity in the Midst of This Business District

Located among the skyscrapers of Shinjuku in the bustling Kabuki-cho district and near the department store, Isetan, this historic shrine is dedicated to a god of the Shinjuku area for business prosperity from before the Edo period. It is also home to the Geino Asama shrine, honoring the god of public entertainment and media. The shrine's signature festival is *Tori-no-Ichi*, (Rooster Market), held on "rooster" days (according to the Chinese zodiac) in November. Stalls sell decorative *kumade* (bamboo rakes)— for raking in money, hopefully! The festival attracts about 600,000 people every year, who buy *kumade* rakes in hopes of thriving businesses, and who also visit the Hanazono jinja Shrine. This is a great place to escape the non-stop chaos of Shinjuku, and most Sundays you will find a flea market with antiques and trinkets.

花園神社

HANAZONO JINJA SHRINE

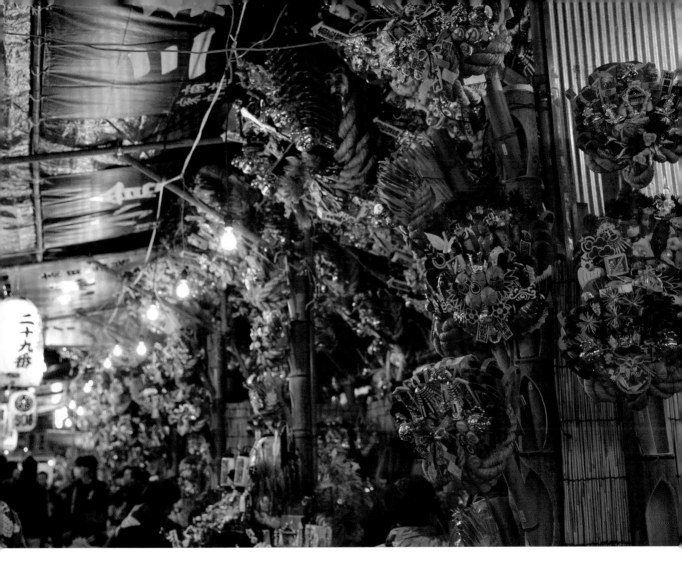

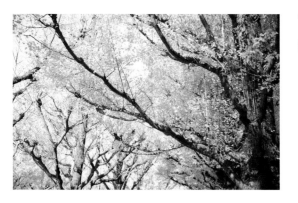

Take a Walk Along One of the Most Beautiful Paths in Tokyo

Icho Namiki (Ginkgo Avenue), in Meiji Jingu Gaien Park, is famous for its ginkgo trees. Just a block away from the subway station, the avenue (at 0.2 miles, 300 meters) is lined with double rows of ginkgo trees, and when the leaves turn brilliant yellow in the autumn it is an amazing sight. Peak time is the last two weeks in November, but it is also beautiful when the leaves fall and they create a golden carpet. A Ginkgo Festival runs from late November to early December, with local foods, clothing and crafts. Visit on weekends when the roads are closed to vehicles and you can take pictures in the middle of the avenue. Nearby Aoyama to Omotesando are great areas to explore, with shopping and trendy cafes. Don't miss Seitoku Kinen Kaigakan (Meiji Memorial Picture Gallery) at the end of the street.

神宮外苑
いちょう並木
JINGU GAIEN GINKGO AVENUE

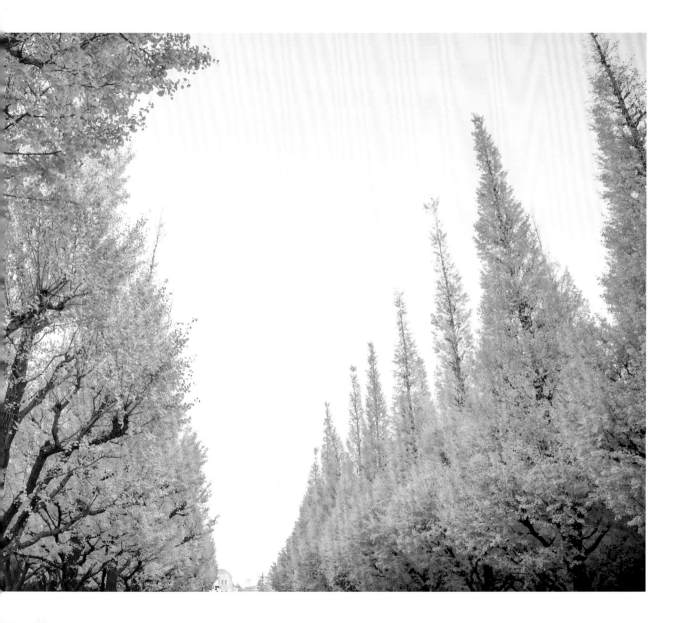

See the Fall Foliage and Weeping Cherry Blossoms in This Peaceful Garden from the Edo Period

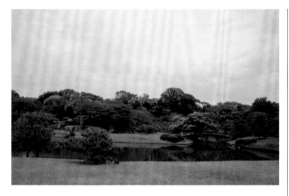

六義園
RIKUGI-EN GARDENS

This garden in the quiet neighborhood of Komagome and Sugamo in the Bunkyo ward is known for its weeping cherry blossoms and autumn foliage. The name, *Rikugien*, translates as "six rules garden," which refers to the rules of *waka* (Japanese poetry) with roots in the Heian period (794-1185). It was built as a strolling garden in the Edo period by Samurai Yanagisawa Yoshiyasu, with the permission of the 5th shogun Tokugawa Tsunayoshi, between 1695 and 1702. Eighty-eight famous views from Japanese and Chinese landscapes have been created in miniature from this garden, however, only 32 remain today. Have a bowl of matcha tea and Japanese sweets in the Fukiage Chaya teahouse under the *bangasa* (red umbrella) and feel like you are back in time. The garden is open late in spring and autumn, when the trees and flowers are magnificently illuminated.

Try Not To Get Dizzy in the Kaleidoscope of Mirrors as You Enter This Shopping Complex

東急プラザ 表参道原宿
TOKYU PLAZA OMOTESANDO HARAJUKU

This fort-like shopping complex, located at the intersection of Omotesando and Meiji-dori, has the most amazing entrance. Ride the escalator up (or down) and you'll be enveloped into a kaleidoscope of mirrors that will surely throw you off balance. Designed by award-winning architect Hiroshi Nakamura and completed in 2012, the shopping complex's multifaceted entranceway looks like something out of a science fiction movie. After you shop in the trendy boutiques, don't miss the lovely sixth-floor rooftop terrace (*Omohara no Mori*) that looks out over the Harajuku area. The terrace and the nearby Starbucks is open from 8:30 a.m. every day. If you are in Harajuku, it is definitely worth the trip here to snap some photos, as this place is unique.

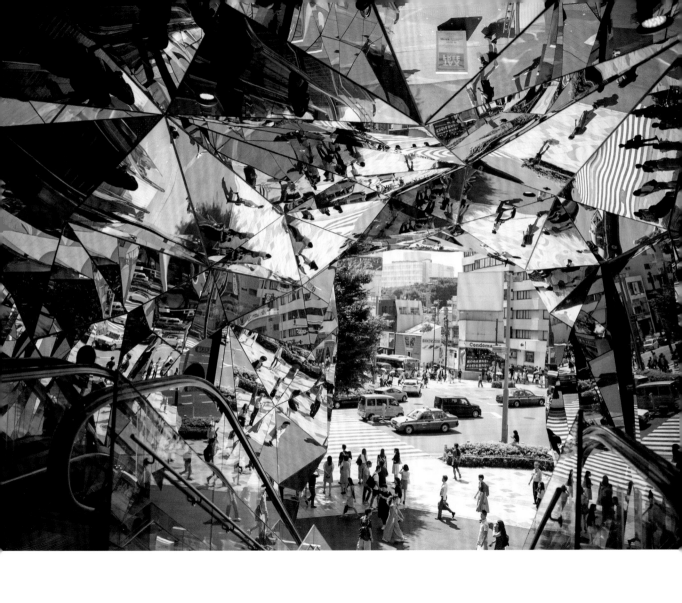

It's a Heavenly Experience to See Mount Fuji
From an Onsen on the Lake!

Mount Fuji—the volcano that is the symbol of Japan (at 12,388 feet—3776 m), is about 62 miles (100 km) southwest of Tokyo. It is an active volcano, and last erupted in 1707. The Fuji Five Lakes (Kawaguchi-ko, Yamanaka-ko, Sai-ko, Shoji-ko, Motosu-ko) are popular for camping, fishing and for summer vacations. I recommend seeing Mount Fuji over the lake. The high season for hiking is July and August, and the route goes from Lake Kawaguchi-ko, and has shops and rest spots. You can also enjoy *onsen* (a hot spring) at a *ryokan* (traditional Japanese inn) and public bath houses across the Fuji Five Lake region. Those along the northeastern shores of Lake Kawaguchi-ko have views of Mount Fuji. If you are lucky, you will see Aka Fuji (Red Fuji, known from the famous *ukiyo-e* by Hokusai, p149) early in the morning. The bus takes just under two hours from Shinjuku Bus Terminal in Tokyo and Kawaguchi-ko Station.

富士山・
河口湖
MOUNT FUJI &
LAKE KAWAGUCHI-KO

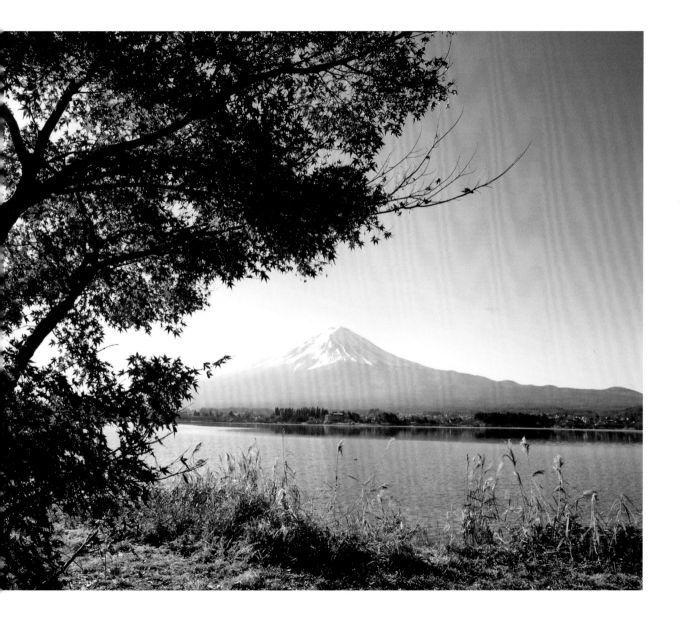

WINTER
AND EARLY SPRING

fuyu

Take a Walk Along the High Fashion
Avenue and See the Striking
Architecture and Designer Shops

Omotesando was built in the 1920s as an entrance of the Meiji-jingu Shrine (the name means "frontal approach"). Along the tree-lined streets, world-famous designer brands such as Louis Vuitton, Bulgari, Dior, Tod's and others have built impressive stores inside of contemporary architecture. Famous landmarks include Omotesando Hills by Ando Tadao, The Audi Forum by Creative Designers International, Tod's building by Toyo Ito and the Prada building by Herzog & de Meuron. More than 90,000 champagne gold LED lights illuminate Omotesando along the Zelkova tree-lined street, and the area has transformed into the chic street of winter lovers. Christmas lights are also put up every year at Omotesando Hills, filling the area with the holiday spirit. Go up on the pedestrian bridge to see the iconic sight of the road illuminated with these special lights.

表参道

OMOTESANDO

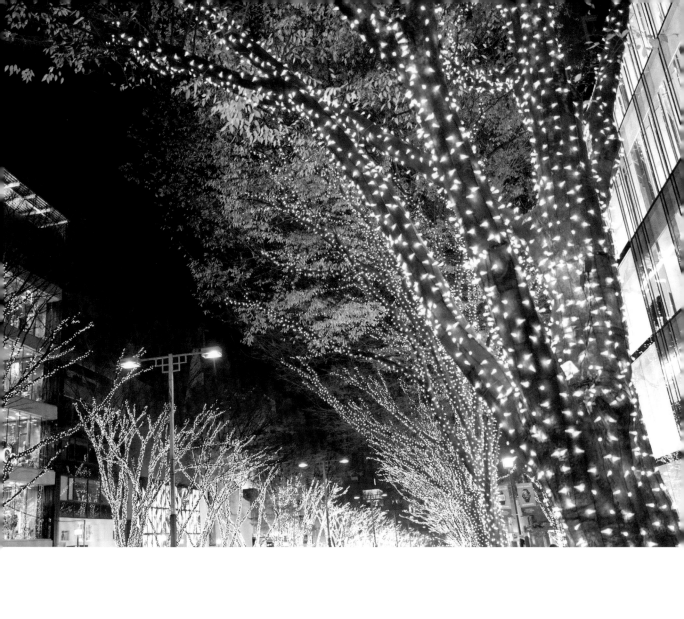

Take a Break in This Peaceful Serene Garden and You Might See a Kimono-clad Bride!

This lovely little garden is a five-minute walk from Mejiro Station. Hidden behind a white wall, the gate opens to a serene world of green and water. It's a popular site for wedding photos and you might see a bride in a traditional *kimono* having her picture taken here. From the end of November to the beginning of December, the garden is lit up and open to the public until 9 p.m. During the day, you can see the colors of the trees reflected on the surface of the pond, and at night the lights create a whole different experience. In winter, pine trees by the shore look artistic because of the elegant *yuki-tsuri* (snow-ropes) fanning out over the tree. Look for the beautifully contrasting colors of the carp swimming under the floating *momiji* (red leaves) in the pond.

目白庭園
MEJIRO GARDEN

Come See the Surfers at This Former Port and
Stay for the Gorgeous Sunset

Once the *samurai* capital of Japan, Kamakura is surrounded by hills on three sides and by the ocean on the other, a major reason the first shogun, Minamoto no Yoritomo (1147-1199) chose Kamakura for the site of his government. *Zaimokuza* (lumber guild) Beach was a busy port during the Kamakura period. Now its sandy beach and very clear water is the perfect place for surfing, paddle boarding, wakeboarding, kayaking and other water sports. Watch the surfers and pick up some pink shells on the beach. During low tide at the east end of the beach you can see Wakae-jima, the remains of the oldest man-made port and the only international port in Japan from the 13th century. When the sun sets, the view of Enoshima Island from the east edge of the coast is truly beautiful. And if you are lucky, you will see Mt. Fuji over Enoshima Island!

材木座海岸・鎌倉

ZAIMOKUZA BEACH / KAMAKURA

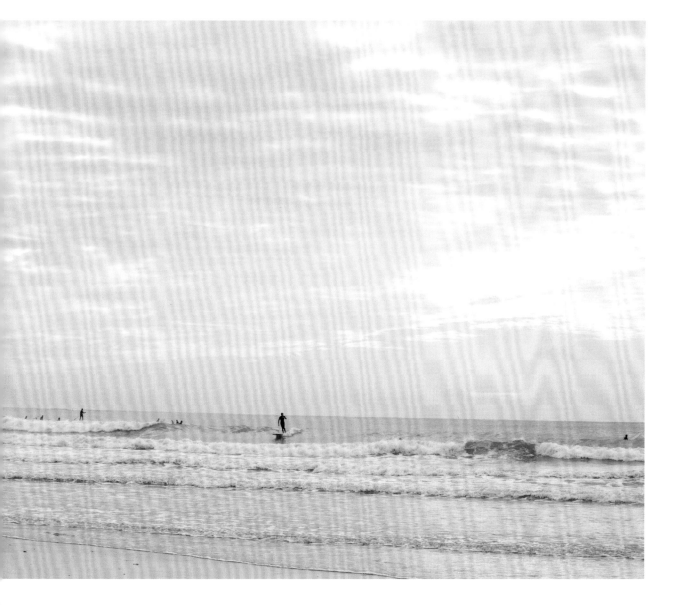

You Can Hide in The Jungle in the Middle of Urban Tokyo

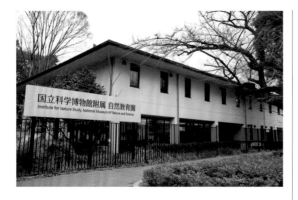

附属自然教育園
INSTITUTE FOR NATURE STUDY

This green oasis, the Institute for Nature Study, is part of the National Museum of Nature and Science. It is hard to believe this 50-acre forest and marshlands is in the middle of central Tokyo. It was the residence and garden of a feudal estate from the Edo period, and then was used as a gunpowder storage site in the Meiji period. Two minutes from the gates you're dwarfed by pines, zelkova and dogwood trees. You'll find ponds, botanical gardens, marshland, and trails. The dense undergrowth mutes sound, and only 300 people are allowed in at a time. An hour or two spent walking along the trails is a peaceful break from the chaos of the city. Seen from the above, it looks like a dense green jungle in the city. You will never tire of walking around and learning about the plants here.

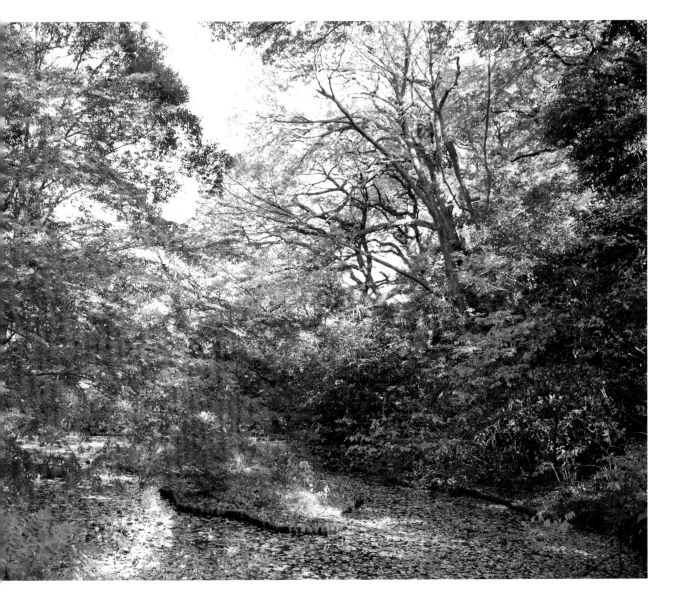

You Can't Say That You Have Visited Japan
Without Tasting *Maguro-Zukushi*

豊洲市場
TOYOSU FISH MARKET

Toyosu Market took over the wholesale fish business from the aging Tsukiji Market, and opened as the "new Tokyo's kitchen" for sushi, restaurants, and for the home on October 11, 2018, on the man-made island of Toyosu in the Bay of Tokyo. The market is open from 5 a.m. to 5 p.m. The famous tuna auction—*maguro no seri*, starts around 5 a.m. (it's a good idea to stay the night before at the nearby hotel, because many can't make it even by the first train). There are almost 40 restaurants here and I highly recommend *Maguro-Zukushi*—with sushi from all kinds of tuna. Then shop for souvenirs at Uogashi Yokocho Market—more than 70 shops sell specialties like *nori* (sea weed) and *kanbutsu* (dry foods). Go up to the rooftop garden early in the morning for views of Tokyo Bay.

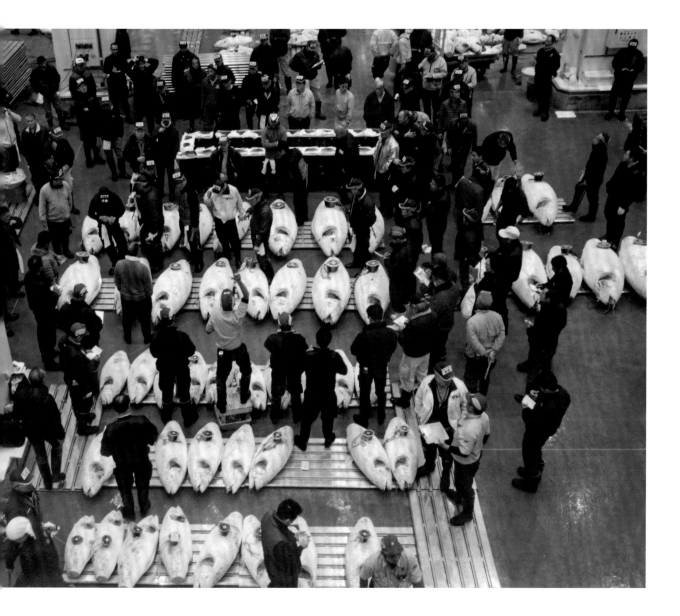

Go Back in Time in This Lovely Art Deco Museum From a Former Imperial Residence

Architecture enthusiasts and Art Deco lovers should not miss the Tokyo Metropolitan Teien Art Museum, just east of Meguro Station. It was built in 1933 as Prince Asaka's residence, who was the husband of Princess Nobuko, a daughter of Emperor Meiji who spent the 1920s in France and the U.S. The residence was converted into a museum 50 years later. The interior was designed mainly by French artists, Henri Rapin (1873-1939) and Ivan-Leon Branchot (1868-1947). The glass relief of the main entrance door and the chandeliers in the grand guest room and great dining hall are by René Lalique (1860-1945). The grounds have both Western and Japanese gardens. Don't miss the beautifully restored tea house. A new Annex contains white cube galleries, a museum shop and a cafe. Enjoy lunch at the cafe with a view of the gardens.

東京都庭園美術館

TOKYO METROPOLITAN TEIEN ART MUSEUM

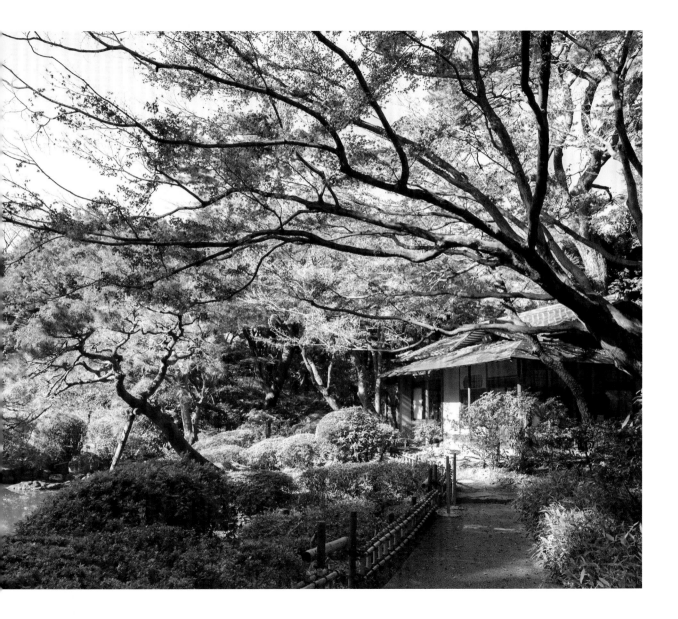

Don't Miss the Blue Lights at the Most Instagram-Worthy Winter Illumination in Tokyo

Ao no Dokutsu (Blue Cave) is one of the best illumination shows in Tokyo. The show began in Nakameguro in 2014 and then moved to Shibuya in 2016. More than two million people from Japan and abroad have attended this event (it has become a popular date spot) and it is now a must-see place in Tokyo in December. With approximately 600,000 blue LED lights, the Blue Cave lights up the avenue of Shibuya, and stretches for about 875 yards (800 m) from Shibuya Koen-dori Street to Yoyogi Park Keyaki Namiki (Zelkova tree-lined). All you can say is "wow!" The blue light creates a mysterious mood, and the experience is amazing. Don't miss this magical winter wonderland!

青の洞窟・渋谷

SHIBUYA BLUE CAVE

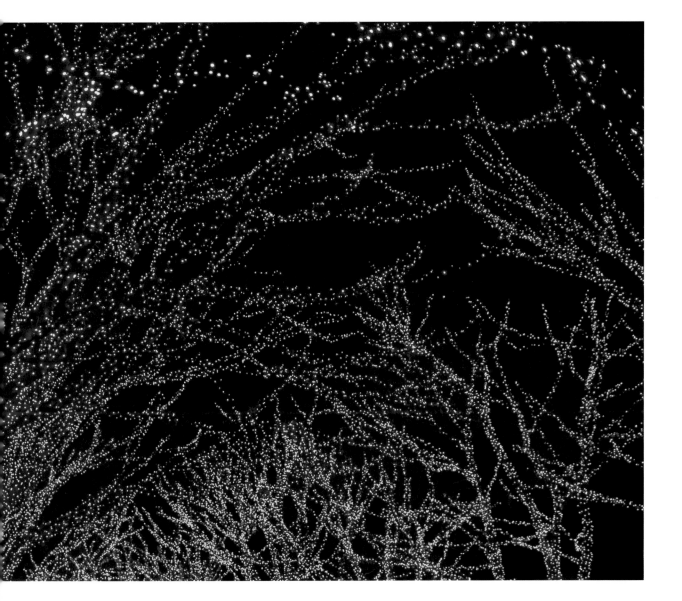

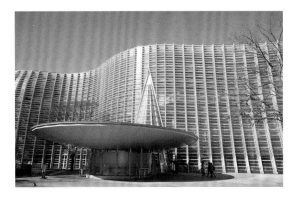

Experience Japan's Exciting Art Scene in This Huge Futuristic Gallery

国立新美術館

THE NATIONAL ART CENTER TOKYO

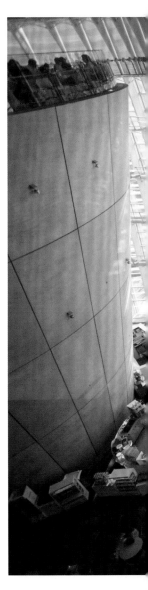

Since it opened in 2007, The National Art Center in Roppongi, the largest exhibition space without having a permanent collection in Japan, has become an important part of Tokyo's art scene. Designed by Kurokawa Kisho, this undulating glass and steel building hosts constantly changing exhibits. Begin with the exhibitions in the two main rooms, which can be historical or contemporary art from Japan and around the world such as Kusama Yayoi, Miyake Issei and Ando Tadao to Titan, Renoir and Modigliani. Then check out the smaller complementary exhibitions, from painting, prints, crafts and calligraphy to a variety of Japanese art and sculpture. Afterward, try one of the four restaurants and cafes—don't miss the tea salon, Salon de Thé Rond, in the shape of an inverse cone, then go to the museum shop for souvenirs.

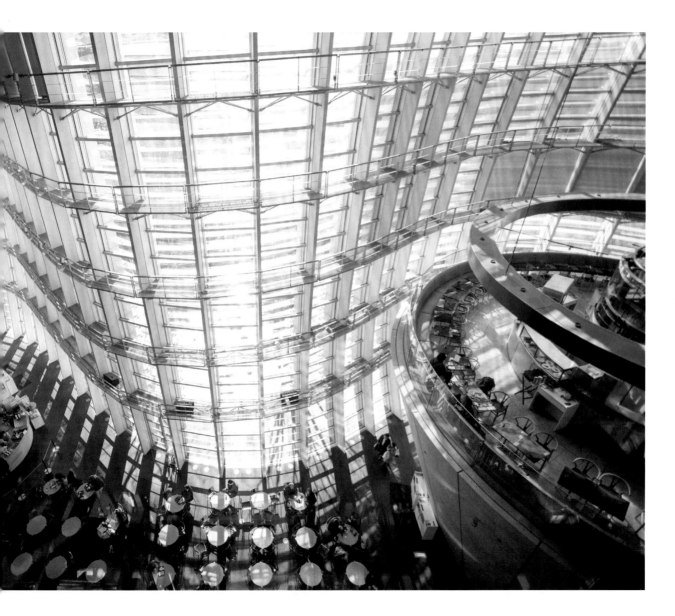

Where Skyscrapers and Japanese Garden Meet for a Tea Ceremony—Have Tea on the Island in the Only Seawater Pond in Tokyo

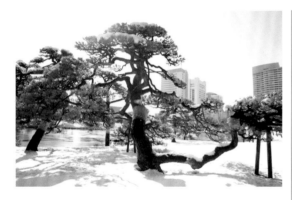

Surrounded by the modern architecture of the Shiodome area, Hama-rikyu Gardens is a secret oasis in the heart of Tokyo. Formerly a second residence and villa for the shogun and the Imperial family after the Meiji Restoration, Hama-rikyu's most distinctive feature is its seawater pond, Shiori no ike, the only remaining seawater pond in Tokyo. The pond has an island, Nakajima, with a tea house, first built in 1707, accessible over wooden footbridges. Green tea and sweets are served in this traditional teahouse setting. Don't miss the 300-year-old pine tree, the *Enryokan*, the Western-style lodge where Ulysses S. Grant stayed, and the duck hunting ponds. From here you can hop on the Tokyo Cruise Water Bus that brings you to the popular tourist areas of Asakusa or Odaiba. Also stop by the Kyushiba-rikyu Garden that is nearby.

浜離宮恩賜庭園
HAMA-RIKYU GARDENS

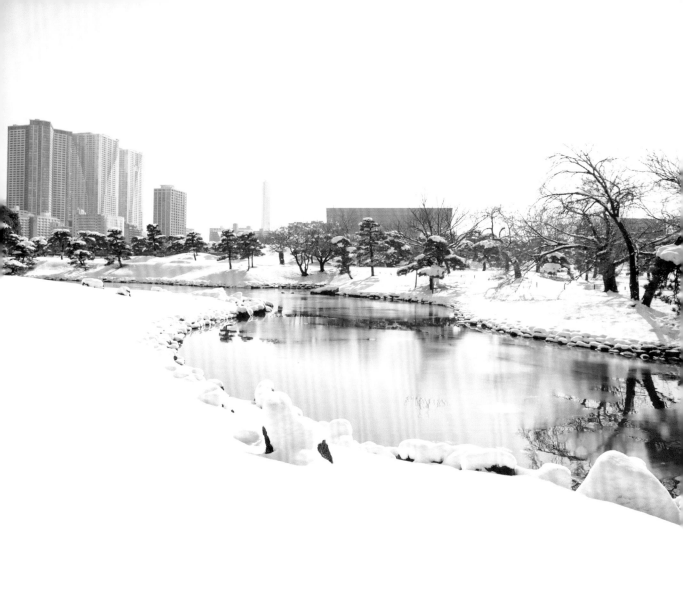

See More Than 60 Varieties of Plum Blossoms and Enjoy All Things Plum at This "Secret" Park

From early February to early March, the Plum Blossom Festival (*Setagaya Ume Matsuri*) is held in Hanegi Park, a symbol of spring in Setagaya ward. Come to see beautiful plum flowers in shades of pink, red and white. In 1967, 55 plum trees were planted here, and now the number has grown to 650, with 60 different varieties. Food stalls offer all things plum, like pickled plum (*umeboshi*), plum tea and drinks. Located near the vintage-clothes shopping mecca, Shimokitazawa, Hanegi Park is the perfect place to relax after shopping. *Amazake* (hot sweet sake with ginger) from *yatai* (food stalls) is super when it's really cold out. Not many people know about this park. Shhh . . . keep it a secret. . . .

羽根木公園
HANEGI PARK

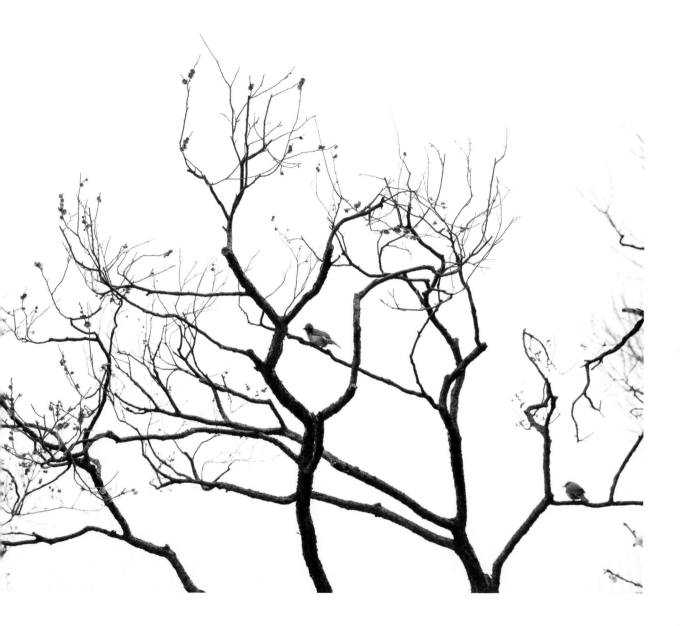

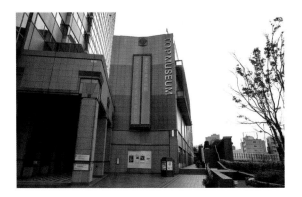

Solely Devoted to Photography and Moving Images, This Museum is One-of-a-Kind, Usually Showing Three Different Exhibitions at Once

東京都
写真美術館

TOP MUSEUM (TOKYO PHOTOGRAPHIC ART MUSEUM)

Located in Ebisu Garden Place— the original home of the Ebisu Beer Brewery—TOP Museum is Japan's premier museum dedicated to photography and video. Formerly known as The Metropolitan Museum of Photography, it was renovated and reopened in 2016. The permanent collection has more than 35,000 works, and the museum presents more than 20 exhibitions a year by domestic and international photographers. Past exhibitions showcased W. Eugene Smith, Nobuyoshi Araki, Dayanita Singh, Hiroshi Sugimoto, Martin Parr, Hiromi Tsuchida, Daido Moriyama, Yuki Onodera, Tomoko Yoneda, Robert Capa, Shimooka Renjo, Erwin Blumenfeld, Robert Doisneau, Berenice Abbott, and more. At Ebisu Garden Place you will also find the Museum of Yebisu Beer by Sapporo. Also popular are the Christmas lights with the world's largest Baccarat chandelier.

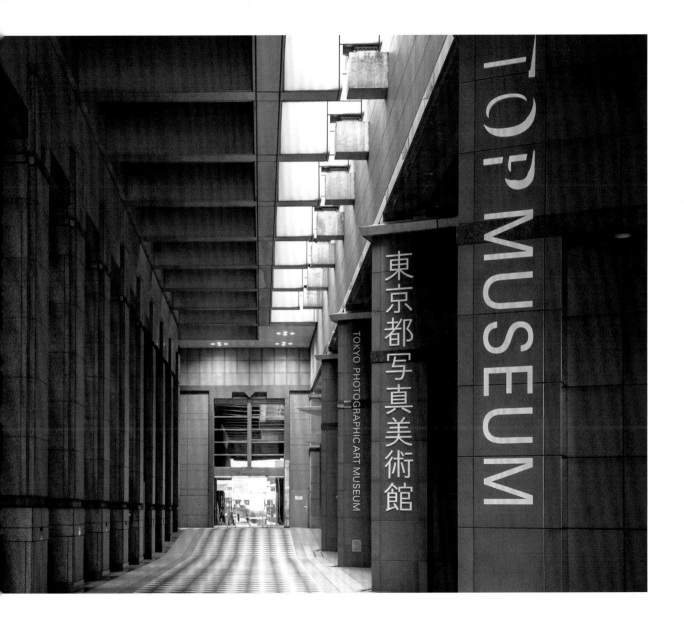

Don't Miss This Shrine From 1180, Kamakura's Spectacular Shrine Compound

Tsurugaoka Hachimangu is the most important shrine in Kamakura, dating back to 1180 when Minamoto no Yoritomo made Kamakura his home, and Kamakura became the capital of Japan (1192–1333). The period is known for the emergence of the *samurai*, the warrior caste, and for the beginning of feudalism in Japan. The grounds contain sub-shrines and several museums. You can arrive along the picturesque, cherry-tree lined Wakamiya-Oji leading from Yuigahama Beach south to the shrine. The main shrine festival takes place September 14-16, with the *Reitai-sai*, a ritual involving the chief priest, offerings and shrine maidens in costume on September 15. This is followed by the colorful *Shinko-sai*, a procession of a portable shrine (*mikoshi*), dances, horses and music. Then *yabusame* (horse-back archery) by riders in Kamakura Period costume takes place on the 16th (another one is in April at the Kamakura Festival). On the Komachi-dori street nearby, don't forget to buy the classic souvenir of Kamakura, *hato sable* (cookies shaped like a pigeon).

鶴岡八幡宮
TSURUGAOKA HACHIMANGU SHRINE / KAMAKURA

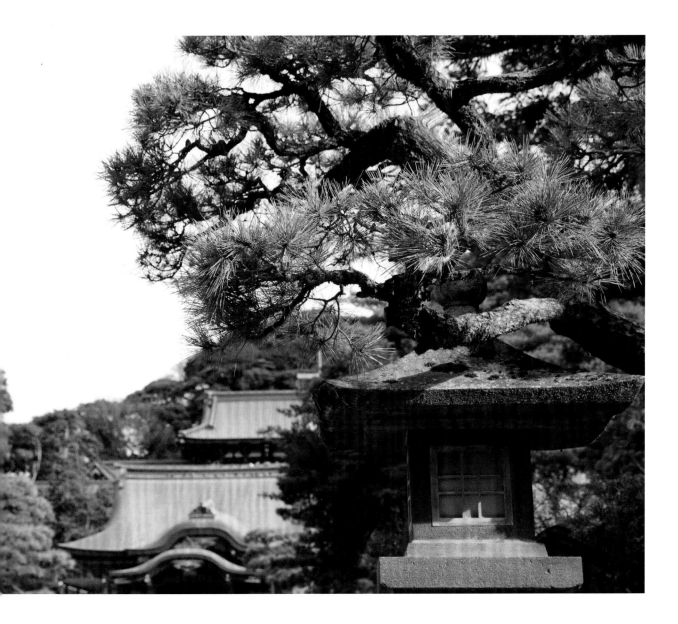

Hear the Big Bangs and See the Magnificent Colors of the Fireworks at Onsen Paradise

熱海
海上花火大会
ATAMI FIREWORKS DISPLAY

Less than an hour away from Tokyo by the *Shinkansen* (bullet train), Atami is the gateway to the beautiful Izu Peninsula, a popular seaside resort area with *onsen* (hot springs) and *ryokan* (traditional Japanese inns), which serve fresh local seafood. Don't miss the Atami Fireworks Festivals, which take place about 15 times throughout the year. The setting in Atami Bay adds incredible acoustics because of the surrounding mountains, as well as a beautiful contrast of colors against the black ocean on the horizon. Impressive colorful fireworks always end with the sensational Sky Niagara Falls finale. The best viewing spots are all along the oceanfront. Come outside! If you watch from your hotel room you will not feel the big bangs reverberating off the mountains behind you. Winter shows are especially nice, when the air is cold and the sky is clear.

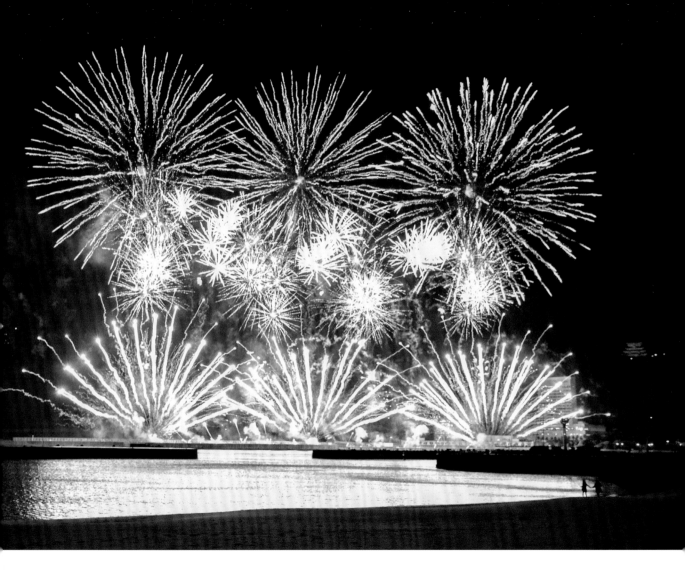

Pray for Passing School Entrance Exams—or a New Beginning—In the Midst of the Blossoms of 300 Plum Trees

Yushima Tenjin Shrine (Yushima Tenmangu) is a Shinto shrine just a five-minute walk from Ueno Park's Shinobazu Pond. Though the shrine was established in 458, like all Tenjin shrines including Kameido Tenjin, it is dedicated to Sugawara Michizane (845-903), the deity of scholarship. Students visit to pray and inscribe *ema*, small wooden plaques, wishing for success with their exams and for acceptance to the university of their choice. The thousands of wooden plaques near the shrine are quite an impressive sight in February and March. You can even find the *ema* of the scholar, poet and politician Michizane riding a cow. The shrine is full of students and parents praying around the same time that over 300 plum blossom trees are in bloom. Wish them and yourself a bright new beginning!

湯島天神
YUSHIMA TENJIN SHRINE

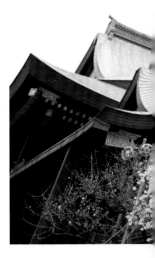

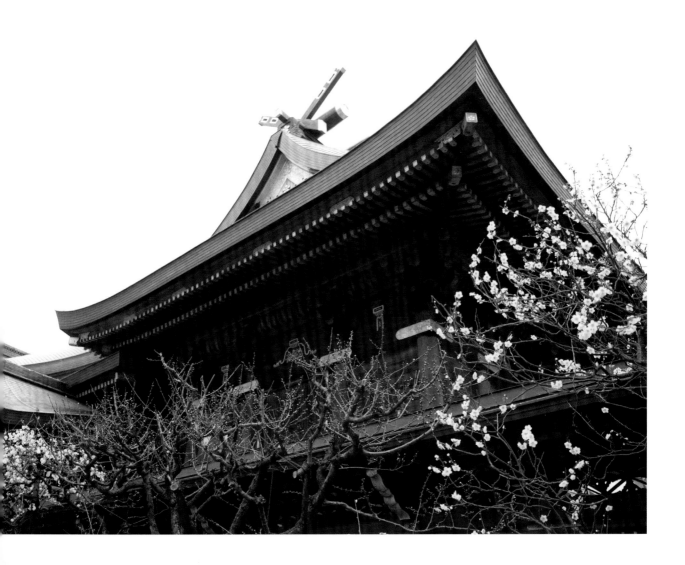

Take Photos From "the Back of the Whale" at This
Rebuilt Pier With Views of the Yokohama Skyline

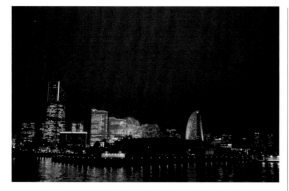

大さん橋
OSANBASHI PIER /
YOKOHAMA

Osanbashi International Passenger Terminal, known as Osanbashi Pier, is Yokohama's oldest pier and the biggest terminal for passenger ships in Japan. Built in 1894, the pier was reconstructed for the 1964 Tokyo Olympics. The current renovation, an enormous 470 yard-long project, was completed in 2002. Designed by UK's Foreign Office Architects, the new design has grass and wooden floorboards that mimic rolling waves. The rooftop is open to the public and nicknamed *kujira no senaka* (the back of a whale) because of its shape. It is a popular spot on sunny days. Surrounded by the sea, you can take photos of the Yokohama landscape with Cosmo World— an amusement park with a ferris wheel, the Red Brick Warehouse, the InterContinental Yokohama Grand Hotel, and the Landmark Tower. It's especially beautiful when it is illuminated after dark.

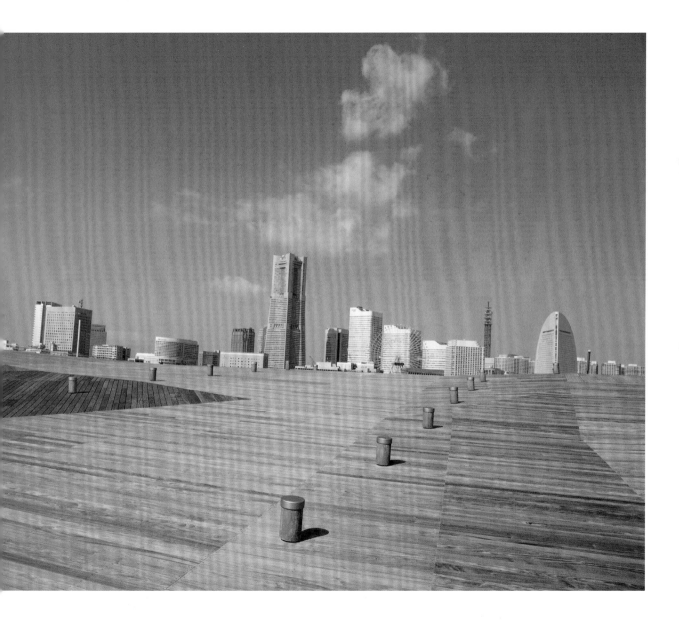

See 17 Historical Buildings From All Over Japan in This Beautiful Year-Round Traditional Japanese Garden

横浜・三渓園

SANKEIEN GARDEN / YOKOHAMA

This 45-acre traditional Japanese garden was once the private home of Sankei Hara (1869-1939), a wealthy silk merchant. The garden opened to the public in 1906. Seventeen historically significant buildings were moved here from all over Japan. The garden's symbol, the three-story pagoda of Kyoto's Old Tomyoji, can be seen from almost anywhere in the garden. Renowned for its seasonal beauty, the garden is resplendent year-round. In late March to early April, the cherry blossoms (*sakura*) are in bloom. In July and August, the pond is covered with thousands of pink lotus blossoms. In late autumn, you can enjoy the changing color of the leaves. Winter is my favorite time here, when the plum blossoms (*ume*) start to bloom in mid to late February. From here, you can go to Motomachi China Town.

Climb Takao-san, the Holy Mountain, and Look Out for Goblins

高尾山
MOUNT TAKAO

It's easy to climb up the 1,965-foot (599 meter) high Mount Takao by foot, or you can ride on a cable car or chairlift. The mountain boasts the highest number of climbers (2.6 million per year) in Japan. It's amazing that you can enjoy the spectacular beauty of nature here, even though it is only a 50-minute walk from Shinjuku. Takao Baigo, a huge plum garden, is a great place to see the Plum Festival (*Ume Matsuri*) in late February to mid March. Takao-san is also known as a holy mountain, home of the *Tengu*, a long-nosed goblin, and also because the 14th-century hermits who practice mountain asceticism live here. The *Tengu* are said to keep a close eye on Mount Takao, and they chase off any evildoers! When you are tired from hiking, enjoy a picnic and *ume* (plum).

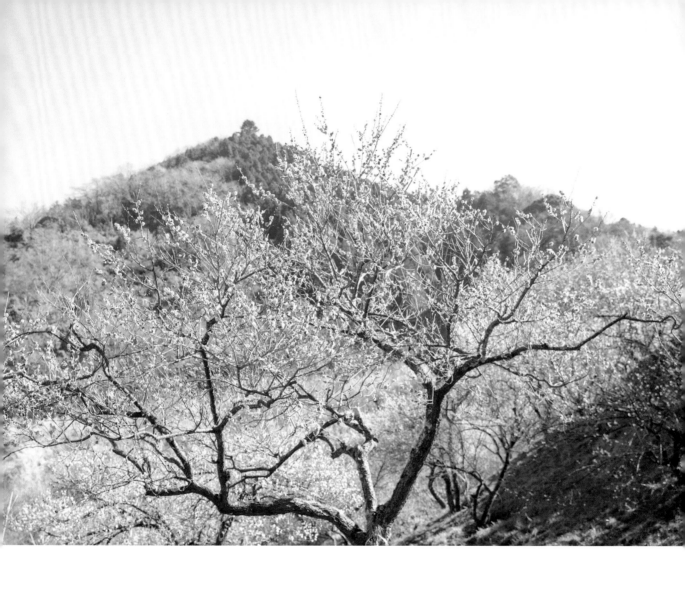

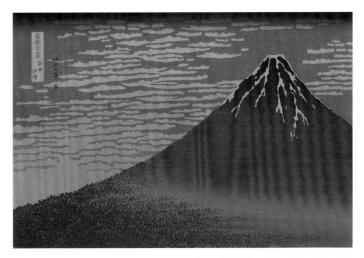

Katsushika Hokusai, South Wind, Clear Sky
(Gaifu kaisei), also known as Red Fuji, from the series
Thirty-six Views of Mount Fuji (Fugaku sanjurokkei),
c. 1830-32, *see p110-111*

TOKYO
MINDSCAPES

Tokyo Calendar

		JAN			FEB			MAR			APR			MAY			JUN		
		Early	Mid	Late	Early	Mid	Late	Early	Mid	Late	Early	Mid	Late	Early	Mid	Late	Early	Mid	Late
FLOWERS	Plum (Ume)				Yushima Tenjin Shrine / Hanegi Park / Rikugien / Mt. Takao / Sankeien Garden														
	Cherry (Sakura)								Shinjuku Gyoen / Inogashira Park / Ueno Park / Kagurazaka / Tokyo Tower, etc.										
	Lit up									Tokyo Midtown / Rikugi-en Garden / Meguro River / Imperial Palace etc.									
	Double Cherry (Yae Sakura)									Shinjuku Gyoen / Ueno Park									
	Wisteria (Fuji)												Kameido Tenjin Shrine / Tsurugaoka Hachimangu Shrine						
	Azalea (Tsutsuji)									Nezu Shrine / Rikugien Garden									
	Rose (Bara)												Yoyogi Park / Hibiya Park / Shinjuku Gyoen						
	Iris (Shobu / Kakitsubata)										Nezu Museum						Koishigawa Korakuen / Kiyosumi Teien		
	Hydrangea (Ajisai)																Meigetsu-in Temple		
	Chrysanthemum (Kiku)																		
	Others	Peony (Botan) at Tsurugaoka Hachimangu											Peony (Botan) at Hama-rikyu Gardens	Poppies & Cornflowers (Yagurumagiku) at Kasai Rinkai Park					
					Camellia (Tsubaki) at Chinzanso								Baby Blue Eyes (Ruri Karakusa) at Showa Memorial Park						
FALL FOLIAGE	Ginkgo (Icho)																		
	Red Maple (Momiji)																		
	Lit up																		
	Fireflies (Hotaru)														Chinzanso				

	JUL			AUG			SEP			OCT			NOV			DEC		
	Early	Mid	Late	Early	Mid	Late	Early	Mid	Late	Early	Mid	Late	Early	Mid	Late	Early	Mid	Late

Yoyogi Park / Hibiya Park / Shinjuku Gyoen

Kameido Tenjin Shrine / Yushima Tenjin Shrine / Meiji Jingu Shrine / Hibiya Park

Lotus (Hasu) at Ueno Park

Bush Clover Tunnel (Hagi) at Mukojima Hyakkaen Gardens

Jingu Gaien Ginkgo Avenue / Showa Memorial Park

Koishigawa Korakuen / Mt. Takao / Yoyogi Park / Shinjuku Gyoen

Rikugien Garden / Chinzanso / Mejiro Garden

		JAN			FEB			MAR			APR			MAY			JUN		
		Early	Mid	Late	Early	Mid	Late	Early	Mid	Late	Early	Mid	Late	Early	Mid	Late	Early	Mid	Late
MARKETS	Morning Glory (Asagao)																		
	Chinese Lantern (Hozuki)																		
FIREWORKS	Atami									Atami		Atami			Atami			Atami	
	Tokyo																		
	Other Areas																Zushi		
BON-ODORI DANCE	Festivals																		
GOLD FISH	Art																		
	Aquarium																		
	Festival																		
WINTER ILLUMINATIONS	Shibuya ward																		
	Minato ward																		
	Meguro ward	Ebisu Garden Place / Meguro River																	
	Chuo ward	Marunouchi																	
TRADITIONAL FESTIVALS	Shrines /Temples	New Year's visit at shrines			Setsubun Sensoji / Zojoji / Kanda Myojin							Yabusame at Tsurugaoka Hachimangu		Kanda Festival Kanda Myojin Shrine* / Sanja Festival (Asakusa)			Sanno Festival at Hie Jinja Shrine*		

| | JUL | | | AUG | | | SEP | | | OCT | | | NOV | | | DEC | |
Early	Mid	Late	Early	Mid	Late	Early	Mid	Late	Early	Mid	Late	Early	Mid	Late	Early	Mid	Late
Iriya Asagao Festival																	
Sensoji Hozuki Market		Kagu-razaka Hozuki Market															
		Atami				Atami								Atami			
	Adachi	Sumida River / Katsu-shika	Edogawa River	Jingu													
		Kamakura															
		Zojoji Temple / Marun-ouchi	Tsukiji Honganji Temple		Sumida Kinshicho Kawachi Ondo												
		JR Ebisu Station	Hanazono Jinja Shrine		Hibiya Park												
		Sugamo Koganji Temple			Roppongi Hills												
Eco Edo Nihonbashi - Art Aquarium																	
Tokyo Kingyo Wonderland at Sumida Aquarium																	
		Edogawa Kingyo Matsuri															
													Shibuya Ao no Dokutsu / Omotesando				
												Tokyo Midtown					
												Roppongi Hills Keyakizaka / Ebisu Garden Place					
												Meguro River					
												Marunouchi					
Tanabata Festival at Tokyo Daijingu Shrine			Fukagawa Festival at Tomioka Hachiman Shrine*			Yabusame at Tsu-rugaoka Hachi-mangu						Tori-no-ichi (Rooster Market) at Hanazono Jinja Shrine			Decora-tive paddle market at Sensoji		

* Tokyo Three Major Festivals

Access to Tokyo Mindscapes

1 Institute for Nature Study
2 Jingu Gaien Ginkgo Avenue
3 The National Art Center Tokyo
4 Nezu Museum
5 Rainbow Bridge & Odaiba
6 Roppongi Hills
7 Taro Okamoto Memorial Museum
8 Tokyo Metropolitan Teien Art Museum
9 Tokyo Midtown
10 Tokyo Tower & Zojo-ji Temple
11 Meiji Jingu Shrine
12 National Noh Theatre
13 Omotesando
14 Shibuya Blue Cave
15 Shibuya Crossing
16 Tokyu Plaza Omotesando Harajuku
17 Yoyogi Park
18 Hara Museum of Contemporary Art
19 Tennozu Isle
20 Meguro Fudoson / Ryusen-ji Temple
21 Meguro River & Meguro Sky Garden
22 TOP Museum (Tokyo Photographic Art Museum)
23 Hanegi Park

24 Todoroki Valley
25 Hibiya Park
26 Imperial Palace & Chidorigafuchi
27 Kanda Festival / Kanda Myojin Shrine
28 National Theatre of Japan
29 Tanabata Festival / Tokyo Daijingu Shrine
30 Tokyo Station
31 Eco Edo Art Aquarium / Nihonbashi
32 Hama-rikyu Gardens
33 Kabuki-za
34 Canal Cafe / Kagurazaka
35 Hanazono Jinja Shrine
36 Shinjuku Gyoen
37 Sunshine Aquarium
38 Mejiro Garden
39 Chinzanso
40 Koishikawa Korakuen Gardens
41 Nezu Jinja Shrine
42 Rikugi-en Gardens
43 Yushima Tenjin Shrine
44 Iriya Asagao Festival / Iriya Kishimojin Temple
45 Senso-ji Temple / Asakusa
46 Ueno Park
47 Mukojima-Hyakkaen Gardens

48 Ryogoku Kokugikan
49 Tokyo Kingyo Wonderland / Sumida Aquarium
50 Kameido Tenjin Shrine
51 Kiyosumi Gardens
52 Toyosu Fish Market
53 Kasai Rinkai Park
54 Night Factory Cruise
55 Osanbashi Pier / Yokohama
56 Sankeien Garden / Yokohama
57 The Great Buddha of Kamakura / Kotoku-in Temple
58 Meigetsu-in Temple / Kita-Kamakura
59 Tsurugaoka Hachimangu Shrine / Kamakura
60 Zaimokuza Beach / Kamakura
61 Kugenuma Beach & Enoshima Island
62 Inogashira Park
63 Showa Memorial Park
64 Mount Takao
65 Mount Fuji & Lake Kawaguchi-ko
66 Atami Fireworks Display
67 Nikko Toshogu Shrine

SETAGAYA

Todoroki Valley

KEYS

🚉 Subway & Private Railroad Station
🚌 Bus
🚶 Walking
🖥 Online Information
✈ Airport

〜〜〜 JR Railroad
——— Subway & Private Railroad
▬▬▬ Highway

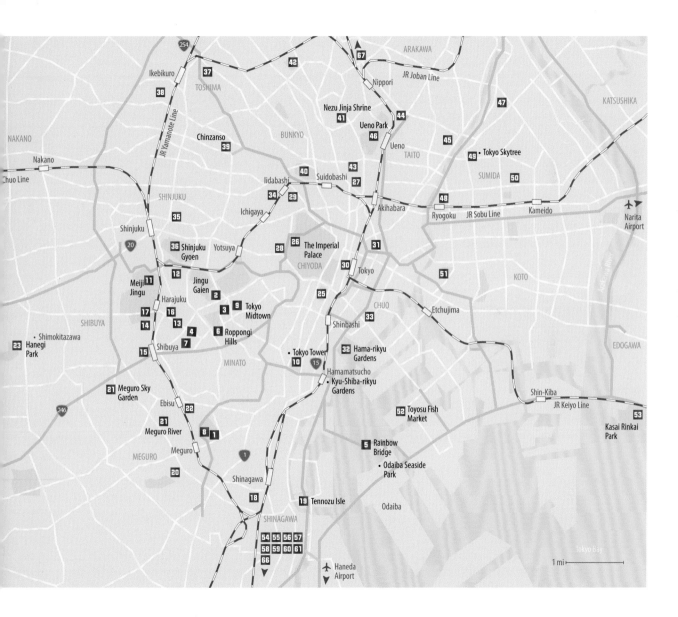

1 Institute for Nature Study (p 120)

5-21-5 Shirokanedai, Minato-ku, Tokyo 108-0071

🚇 Meguro (JR Yamate / Tokyu Meguro Lines) 🚶 9 min.

Shirokanedai (Namboku / Mita Lines) 🚶 7 min.

9am–4:30pm (5pm May 1–Aug 31) Closed Mondays

🖥 ins.kahaku.go.jp/english/index.php

2 Jingu Gaien Ginkgo Avenue (p 104)

2-1 Kita-aoyama, Minato-ku, Tokyo 107-0061

🚇 Aoyama-itchome (Hanzomon / Ginza / Oedo Lines) 🚶 3 min.

🖥 japan.travel/en/spot/378

3 The National Art Center Tokyo (p 128)

7-22-2 Roppongi, Minato-ku, Tokyo 106-8558

🚇 Nogizaka (Chiyoda Line) E6 🚶 1 min. Roppongi

(Oedo / Hibiya Lines) 🚶 5 min.

10am–6pm (8pm Fridays and Saturdays), Closed Tusedays

🖥 nact.jp/english/

4 Nezu Museum (p 90)

6-5-1 Minami-aoyama, Mitato-ku, Tokyo 107-0062

🚇 Omotesando (Ginza / Chiyoda / Hanzomon Lines) 🚶 8 min.

10am–5pm, Closed Mondays

🖥 nezu-muse.or.jp/en

5 Rainbow Bridge & Odaiba (p 94)

[Odaiba Waterfront] 1 Daiba, Minato-ku, Tokyo 135-0091

🚇 Odaiba Kaihin Koen or Daiba (Yurikamome Line),

Tokyo Teleport (Rinkai Line)

🖥 japan.travel/en/spot/1642/

6 Roppongi Hills (p 46)

6-10-1 Roppongi, Minato-ku, Tokyo 106-6108

🚇 Roppongi (Hibiya / Oedo / Chiyoda Lines) 🚶 6 min.

🖥 roppongihills.com/en

7 Taro Okamoto Memorial Museum (p 78)

6-1-19 Minami Aoyama, Minato-ku, Tokyo 107-0062

🚇 Omotesando (Ginza / Chiyoda / Hanzomon Lines)

🚶 8 min. 10am–6pm, Closed Tusedays

🖥 taro-okamoto.or.jp/en

8 Tokyo Metropolitan Teien Art Museum (p 124)

5-21-9, Shirokanedai, Minato-ku Tokyo, 108-0071

🚇 Meguro (JR Yamate / Tokyu Meguro Lines) 🚶 7 min.

Shiroganedai (Namboku / Mita Lines) 🚶 6 min.

10am–6pm, Closed 2nd and 4th Wednesdays

🖥 teien-art-museum.ne.jp/en

9 Tokyo Midtown (p 12)

9-7-1 Akasaka, Minato-ku, Tokyo 107-0052

🚇 Roppongi (Oedo / Hibiya Lines) E8 🚶 1 min

🖥 tokyo-midtown.com/en

10 Tokyo Tower & Zojo-ji Temple (p 18)

[Tokyo Tower] 4-2-8 Shibakoen, Minato, Tokyo 105-0011

🚇 Akabanebashi (Oedo Line) 🚶 5 min. Shiba Koen or Onarimon

(Mita Line), Daimon (Asakusa / Oedo Lines), Kamiya-cho (Hibiya Line),

Hamamatsucho (JR Yamanote Line / Tokyo Monorail)

9am–11pm, Open 7 days

🖥 tokyotower.co.jp/en.html

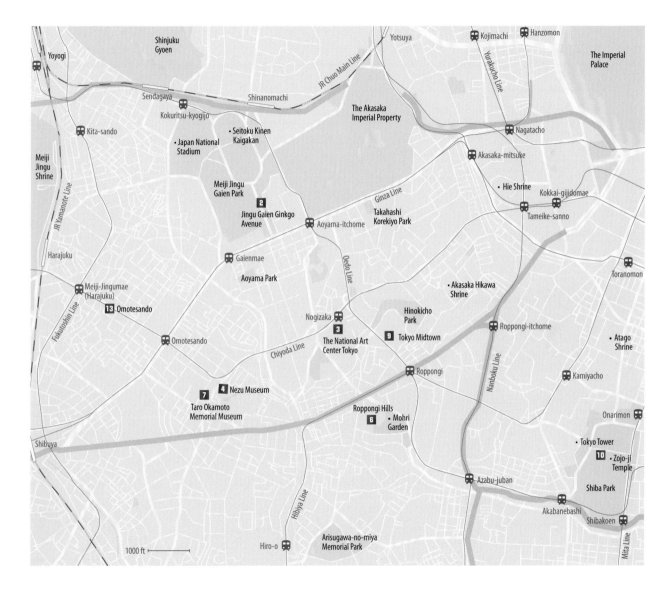

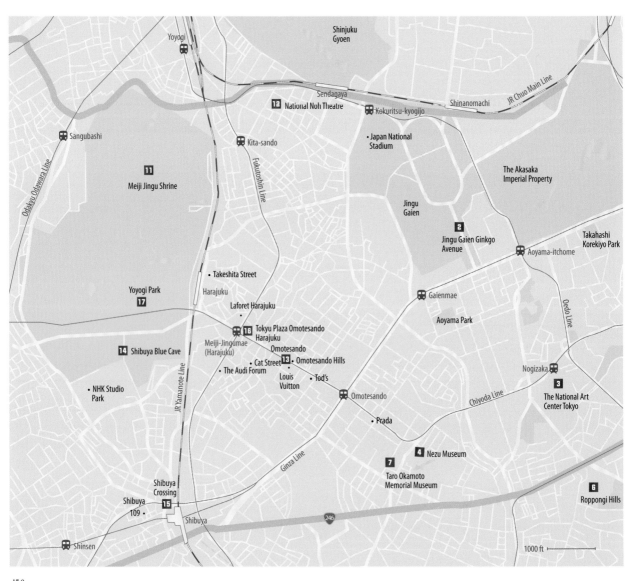

Yoyogi

Shinjuku
Gyoen

Sendagaya

18 National Noh Theatre

Kokuritsu-kyogijo

JR Chuo Main Line

Shinanomachi

Sangubashi

Kita-sando

• Japan National
Stadium

The Akasaka
Imperial Property

11
Meiji Jingu Shrine

Fukutoshin Line

Jingu
Gaien

2
Jingu Gaien Ginkgo
Avenue

Takahashi
Korekiyo Park

Odakyu Odawara Line

• Takeshita Street

Aoyama-itchome

Harajuku

Yoyogi Park

17

Laforet Harajuku

Tokyu Plaza Omotesando
Harajuku

Gaienmae

Aoyama Park

Oedo Line

16

14 Shibuya Blue Cave

Meiji-Jingúmae
(Harajuku)

Omotesando

• Cat Street

13 • Omotesando Hills

Nogizaka

JR Yamanote Line

• The Audi Forum

Louis
Vuitton

• Tod's

Chiyoda Line

3
The National Art
Center Tokyo

• NHK Studio
Park

Omotesando

• Prada

Ginza Line

4 Nezu Museum

Shibuya
Crossing

Shibuya
109 •

15

Shibuya

7

Taro Okamoto
Memorial Museum

6

Roppongi Hills

246

1000 ft

Shinsen

158

SHIBUYA WARD

11 Meiji Jingu Shrine (p 96)

1-1 Yoyogi-kamizono-cho, Shibuya-ku, Tokyo 151-8557

🚇 Harajuku (JR Yamanote Line) 🚶 1 min. Meiji Jingu-mae (Fukutoshin / Chiyoda Lines), Sangubashi (Odakyu Line) 🚶 5 min.

Sunrise–Sunset, Open 7 days

🖥 meijijingu.or.jp/english

12 National Noh Theatre (p 26)

4-18-1, Sendagaya, Shibuya-ku, Tokyo 151-0051

🚇 Sendagaya (JR Chuo / JR Soubu Lines), Kokuritsu Kyogi-jo (Oedo Line) 🚶 5 min. Kitasando (Fukutoshin Line) 🚶 7 min.

🖥 ntj.jac.go.jp/english/schedule/national-noh-theatre.html

13 Omotesando (p 114)

[Omotesando Hills] 4-12-10, Jingu-mae, Shibuya-ku, Tokyo 150-0001

🚇 Omote-sando (Hanzomon / Ginza / Chiyoda Lines) 🚶 2 min. Meiji Jingu-mae (Fukutoshin / Chiyoda Lines), Harajuku (JR Yamanote Line)

Shop: 11am–9pm (8pm Sundays), Restaurant: 11am–11:30pm

🖥 omotesandohills.com/en

14 Shibuya Blue Cave (p 126)

[Keyaki Namiki, Yoyogi Park] 1-5-11, Jinnan, Shibuya-ku, Tokyo 150-0041

🚇 Shibuya (JR Yamanote / JR Saikyo / Ginza / Hanzomon / Fukutoshin / Keio Inogashira / Tokyu Toyoko / Tokyu Denentoshi Lines) 🚶 5 min.

5pm–10pm in December

🖥 shibuya-aonodokutsu.jp

15 Shibuya Crossing (p 76)

[Shibuya 109] 2-29-1 Dogenzaka, Shibuya-ku Tokyo 150-0043

🚇 Shibuya (JR Yamanote / JR Saikyo / Ginza / Hanzomon / Fukutoshin / Tokyu Toyoko / Tokyu Denentoshi Lines) 🚶 1 min.

🖥 japan.travel/en/spot/2109

16 Tokyu Plaza Omotesando Harajuku (p 108)

4-30-3 Jingumae, Shibuya-ku, Tokyo, 150-0001

🚇 Harajuku (JR Yamanote Line) 🚶 4 min. Meiji-jingumae (Chiyota Line /Fukutoshin Lines) 🚶 1 min. Omotesando (Chiyoda / Hanzomon /Ginza Lines) 🚶 7 min.

Shop: 11am–9pm Rooftop Garden: 8:30am–9pm

🖥 omohara.tokyu-plaza.com/en/

17 Yoyogi Park (p 88)

2-1 Yoyogi-kamizono-chō, Shibuya-ku, Tōkyō 151-0052

🚇 Harajuku (UR Yamanote Line), Meiji Jingu-mae (Fukutoshin / Chiyoda Lines), Yoyogi Koen (Chiyoda Line) 🚶 3 min. Yoyogi Hachiman (Odakyu Line) 🚶 6 min.

5am–8pm (May 1–Oct 15), 5am–5pm (Oct 16–Apr 30)

🖥 japan.travel/en/spot/1654/

18 Hara Museum of Contemporary Art (p 36)
4-7-25 Kita-Shinagawa, Shinagawa-ku, Tokyo 140-0001
🚉 Shinagawa (JR Yamanote / Keihin Kyuko Lines) 🚶 15 min.
Kita-shinagawa (Keihin Kyuko Line) 🚶 8 min.
11am–5pm (8pm on Wednesdays), Closed Mondays
💻 haramuseum.or.jp/en/hara/

19 Tennozu Isle (p 52)
2-1 Higashi-shinagawa, Shinagawa-ku, Tokyo 140-0002
🚉 Tennozu Isle (Rinkai Line / Monorail) 🚶 1 min.
💻 e-tennoz.com/en

20 Meguro Fudoson / Ryusen-ji Temple (p 30)
3-20-26 Shimomeguro, Meguro, Tokyo 153-0064
🚉 Fudo-mae (Tokyu Meguro Line) 🚶 15 min.
Meguro (JR Line) 🚶 13 min.
💻 en.japantravel.com/tokyo/meguro-fudoson-temple/38035

21 Meguro River & Meguro Sky Garden (p 14)
[Nakameguro] 2-2 Nakameguro, Meguro-ku, Tokyo 153-0061
🚉 Nakameguro (Tokyu Toyoko / Hibiya Lines) 🚶 5 min.
💻 japan.travel/en/spot/377/
[Meguro Sky Garden] 1-9-2 Ohashi, Meguro-ku, Tokyo 153-0044
🚉 Ikejiri-ohashi (Tokyu Denen-toshi Line) 🚶 3 min.
7am–9pm, Open 7 days
💻 gotokyo.org/en/spot/649/

22 TOP Museum (Tokyo Photographic Art Museum) (p 134)
Yebisu Garden Place, 1-13-3 Mita Meguro-ku Tokyo 153-0062
🚉 Ebisu (JR Line) 🚶 7 min. Ebisu (Hibiya Line)
10am–6pm (8pm on Thursdays and Fridays), Closed Mondays
💻 topmuseum.jp/e/contents/index.html

23 Hanegi Park (p 132)
4-38-52 Daita, Setagaya-ku, Tokyo 155-0033
🚉 Umegaoka (Odakyu Line) 🚶 5 min. Higashi Matsubara
(Inogashira Line) 🚶 7 min.
💻 gotokyo.org/en/spot/509/

24 Todoroki Valley (p 74)
1-22, 2-37~38 Todoroki, Setagaya-ku, Tokyo 158-0082
🚉 Todoroki Keikoku (Tokyu Oimachi Line) 🚶 3 min.
💻 gotokyo.org/en/spot/27/

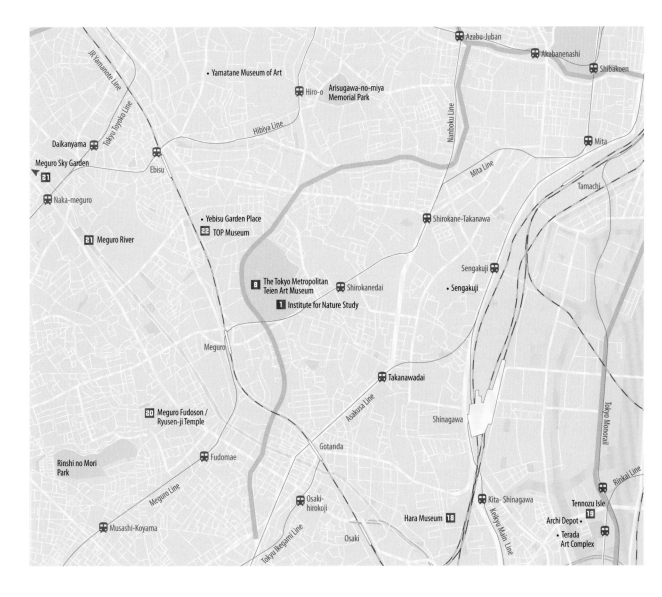

- Yamatane Museum of Art

Hiro-o

Arisugawa-no-miya
Memorial Park

Azabu-Juban

Akabanenashi

Shibakoen

JR Yamanote Line

Tokyu Toyoko Line

Hibiya Line

Daikanyama

Meguro Sky Garden

21

Ebisu

Naka-meguro

21 Meguro River

- Yebisu Garden Place
22 TOP Museum

8 The Tokyo Metropolitan
Teien Art Museum

1 Institute for Nature Study

Shirokanedai

Nanboku Line

Mita Line

Mita

Tamachi

Shirokane-Takanawa

Sengakuji

Sengakuji

- Sengakuji

Meguro

Takanawadai

Asakusa Line

Shinagawa

Tokyo Monorail

Meguro Fudoson /
Ryusen-ji Temple

20

Fudomae

Gotanda

Rinshi no Mori
Park

Meguro Line

Osaki-
hirokoji

Kita- Shinagawa

Keikyu Main Line

Rinkai Line

Tennozu Isle

19

Archi Depot •

Musashi-Koyama

Tokyu Ikegami Line

Osaki

Hara Museum **18**

- Terada
Art Complex

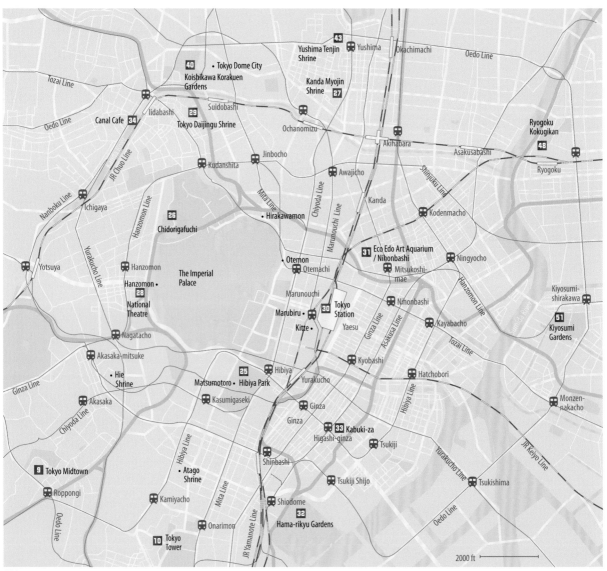

Yushima Tenjin Shrine
43 Yushima
Okachimachi
Oedo Line

40 • Tokyo Dome City
Koishikawa Korakuen Gardens

Kanda Myojin Shrine
27

Ryogoku Kokugikan

Tozai Line

Oedo Line

Canal Cafe **34**
Iidabashi
29
Tokyo Daijingu Shrine
Suidobashi

Ochanomizu
Akihabara
Asakusabashi

48
Ryogoku

JR Chuo Line

Jinbocho

Kudanshita

Awajicho

Kanda

Shinjuku Line

Nanboku Line
Ichigaya

Hanzomon Line

26
Chidorigafuchi

• Hirakawamon

Mita Line

Marunouchi Line

Chiyoda Line

Kodenmacho

Kiyosumi-shirakawa

Yurakucho Line

Yotsuya

Hanzomon
Hanzomon
28
National Theatre

The Imperial Palace

• Otemon
Otemachi

31 Eco Edo Art Aquarium / Nihonbashi
Mitsukoshi-mae

Ningyocho

Hanzomon Line

51
Kiyosumi Gardens

Nagatacho

Marunouchi

Marubiru **30** Tokyo Station
Kitte •
Yaesu

Nihonbashi

Kayabacho

Tozai Line

Akasaka-mitsuke

• Hie Shrine

25 • Hibiya
Matsumotoro • Hibiya Park

Kyobashi

Hatchobori

Ginza Line

Kasumigaseki

Yurakucho

Hibiya Line

Monzen-nakacho

Chiyoda Line
Akasaka

Ginza Line
Ginza

Ginza

33 Kabuki-za
Higashi-ginza
Tsukiji

JR Keiyo Line

9 Tokyo Midtown

• Atago Shrine

Hibiya Line

Shinbashi

Tsukiji Shijo

Yurakucho Line

Tsukishima

Roppongi

Kamiyacho

Mita Line

Shiodome
32
Hama-rikyu Gardens

Onarimon

Oedo Line

JR Yamanote Line

10 Tokyo Tower

2000 ft

162

CHIYODA AND CHUO WARDS

25 Hibiya Park (p 100)

1-6 Hibiiya-koen, Chiyoda-ku, Tokyo 100-0012

🚃 Hibiya Station (Hibiya / Chiyoda / Mita Lines),
Kasumigaseki (Marunouchi / Chiyoda Lines) 🚶 1 min.

🖥 japan.travel/en/spot/1733

26 Imperial Palace & Chidorigafuchi (p 20)

Kudanminami 2 to 3, Chiyoda-ku, Tokyo

🚃 Kudanshita or Hanzomon (Hanzomon Line) 🚶 5 min.

🖥 japan.travel/en/spot/1736/

27 Kanda Festival / Kanda Myojin Shrine (p 34)

[Kanda Myojin Shrine] 2-16-2 Sotokanda, Chiyoda-ku, Tokyo 101-0021

🚃 Ochanomizu (JR Sobu / Marunouchi Line), Shin-ochanomizu
(Chiyoda Line), Suehiro-cho (Ginza Line) 🚶 5 min. Akihabara (Hibiya /
Keihin Tohoku / JR Yamanote Lines) 🚶 7 min.

Weekend around May 15

🖥 japan.travel/en/spot/392/

28 National Theatre of Japan (p 22)

4-1 Hayabusa-cho, Chiyoda-ku, Tokyo 102-8656

🚃 Hanzomon (Hanzomon Line) 🚶 5 min. Nagatacho (Yurakucho /
Hanzomon / Namboku Lines)

🖥 ntj.jac.go.jp/english/access/facilities_01.html

29 Tanabata Festival / Tokyo Daijingu Shrine (p 62)

2-4-1 Fujimi, Chiyoda-ku, Tokyo 102-0071

🚃 Iidabashi (Yorakucho / Nanboku / Tozai / Oedo / JR Chuo / JR
Soubu Lines) 🚶 5 min.

6am–9pm, Open 7 days

🖥 tokyodaijingu.or.jp/english

30 Tokyo Station (p 50)

[Marunouchi Building] 1-9 Marunouchi, Chiyoda-ku, Tokyo

🚃 Tokyo (JR Shinkansen / JR Tokaido / JR Yamanote / JR Chuo /
JR Soubu / JR Yokosuka / Keiyo / Narita Express / Keihin Took /
Marunouchi Lines) 🚶 1 min.

🖥 japan.travel/en/spot/1710/

31 Eco Edo Art Aquarium / Nihonbashi (p 80)

[Nihionbashi Mitsui Hall] 4F, 2-2-1 Nihonbashi-muromachi,
Chuo-ku, Tokyo 103-0022

🚃 Mitsukoshi-mae (Giinza / Hanzomon Lines) 🚶 1 min.
Shin-nihonbashi (JR Soubu Line)

🖥 artaquarium.jp/en

32 Hama-rikyu Gardens (p 130)

1-1, Hama Rikyu-teien, Chuo-ku, Tokyo 104-0046

🚃 Tsukiji Shijo / Shiodome (Oedo Line), Shiodome (Yurikamome
Line) 🚶 7 min. Shinbashi (JR Yamanote / Ginza /
Asakusa Lines) 🚶 12 min.

9am–5pm, Open 7 days

🖥 teien.tokyo-park.or.jp/en/hama-rikyu/

33 Kabuki-za (p 48)

4-12-15 Ginza, Chuo-ku, Toyo 104-0061

🚃 Higashi-ginza (Hibiya Line) 🚶 1 min.

🖥 kabukiweb.net/theatres/kabukiza/information/index.html

34 Canal Cafe / Kagurazaka (p 16)

[Canal Cafe] 1-9 Kagurazaka, Shinjuku-ku, Tokyo 162-0825

🚇 Iidabashi (JR Soubu / JR Chuo / Oedo / Tozai Lines) 🚶 3 min.

11:30–11pm (9:30pm Sundays), Closed first and third Mondays

🖥 japan.travel/en/spot/1703/

35 Hanazono Jinja Shrine (p 102)

5-17-3 Shinjuku, Shinjuku-ku, Tokyo 160-0022

🚇 Shinjuku-sanchome (Toei Shinjuku / Marunouchi / Fukutoshin Lines) E2 🚶 1 min. Shinjuku (JR / Odakyu / Keio Lines) 🚶 7 min.

8am–8pm, Open 7 days

🖥 visiting-japan.com/en/articles/tokyo/e13sj-hanazono-jinja

36 Shinjuku Gyoen (p 8)

11 Naito-machi, Shinjuku-ku, Tokyo 160-0014

🚇 Shinjuku-Gyoenmae (Marunouchi Line) E1 🚶 5 min. Sendagaya (JR Sobu Line) 🚶 5 min.

🖥 japan.travel/en/spot/1659/

37 Sunshine Aquarium (p 58)

World Import Mart Building, 3-1, Shigashi-ikebukuro Toshima-ku, Tokyo 170-0013

🚇 Higashi-ikebukuro (Yurakucho Line) 🚶 3 min. Ikebukuro (JR / Seibu / Tobu / Marunouchi / Fukutoshin Lines) 🚶 8 min.

10am–8pm (6pm Nov 1–Mar 31), Open 7 days

🖥 sunshinecity-global.com/en

38 Mejiro Garden (p 116)

3-20-18 Mejiro, Toshima-ku Tokyo 171-0031

🚇 Mejiro (JR Yamanote Line) 🚶 5 min.

9am–5pm (7pm Jul and Aug), Closed 2nd and 4th Mondays

🖥 gotokyo.org/en/spot/644/

39 Chinzanso (p 92)

2-10-8 Sekiguchi, Bunkyo-ku, Tokyo

🚇 Mejiro (JR Yamanote Line) 🚌 10min. Edogawabashi (Yurakucho Line) E1a 🚶 10 min.

🖥 hotel-chinzanso-tokyo.com/garden/

40 Koishikawa Korakuen Gardens (p 54)

1-6-6 Koraku, Bunkyō-ku, Tokyo 112-0004

🚇 Iidabashi (Oedo Line) E06-C3 🚶 3 min. Iidabashi (JR Soubu / JR Chuo / Tozai / Yurakucho / Namboku Lines), Korakuen (Marunouchi / Namboku Line) 🚶 8 min., 9am–5pm, Open 7 days

🖥 gotokyo.org/en/spot/24/

41 Nezu Jinja Shrine (p 28)

1-28-9 Nezu, Bunkyo-ku, Tokyo 113-0031

🚇 Nezu or Sendagi (Chiyoda Line) E1 🚶 5 min. Todai-mae (Namboku Line), Hakusan (Mita Line)

🖥 japan.travel/en/spot/1695/

42 Rikugi-en Gardens (p 106)

6-16-3 Hon-komagome, Bunkyo-ku, Tokyo 113-0021

🚇 Komagome (JR Yamanote / Namboku Lines) 🚶 7 min. Sengoku (Mita Line) 🚶 10 min., 9am–5pm, Open 7 days

🖥 japan.travel/en/spot/1693/

43 Yushima Tenjin Shrine (p 140)

3-30-1 Yushima, Bunkyo-ku, Tokyo 113-0034

🚇 Yushima (Chiyoda Line) 🚶 2 min. Ueno Hirokoji (Ginza Line), Hongo 3 chome (Marunouchi Line), Ueno Okachi-machi (Oedo Line), Okachi-machi (JR Yamanote / Keihin Tohoku Lines)

6am–8pm, Open 7 days

🖥 japan.travel/en/spot/1672/

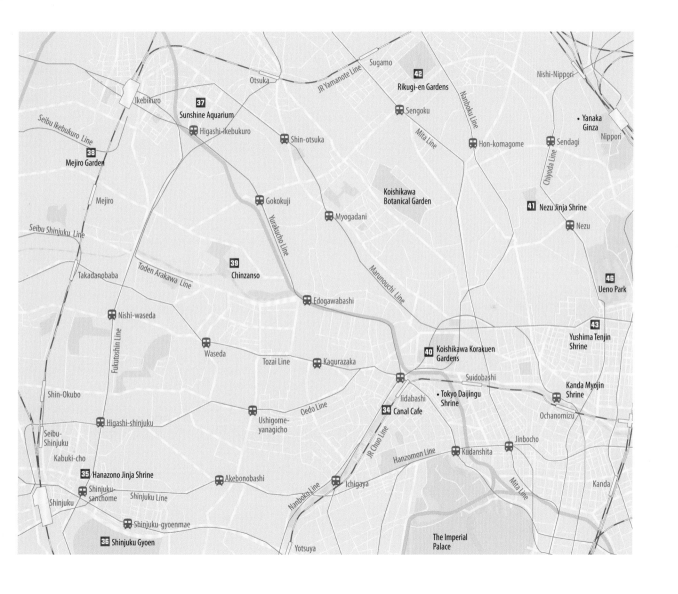

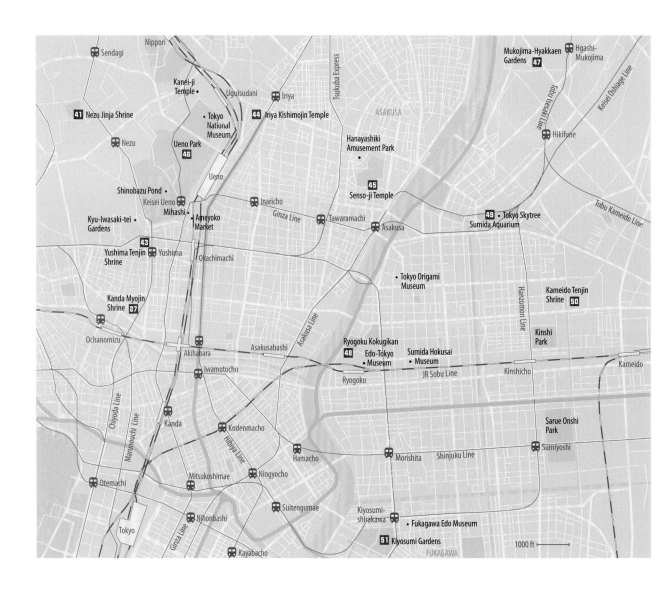

Sendagi

Nippori

Kanei-ji
Temple •

Uguisudani

Iriya

41 Nezu Jinja Shrine

Tokyo
National
Museum

44 Iriya Kishimojin Temple

ASAKUSA

Tsukuba Express

Mukojima-Hyakkaen
Gardens **47**

Hgashi-
Mukojima

Nezu

Ueno Park
46

Hanayashiki
Amusement Park

Hikifune

Tobu Isesaki Line

Keisei Oshiage Line

Ueno

Shinobazu Pond •

45

Senso-ji Temple

Tobu Kameido Line

Keisei Ueno

Inaricho

Mihashi

Ameyoko
Market

Ginza Line

Tawaramachi

49 • Tokyo Skytree

Kyu-Iwasaki-tei
Gardens

Asakusa

Sumida Aquarium

43

Yushima Tenjin
Shrine

Yushima

Okachimachi

• Tokyo Origami
Museum

Kameido Tenjin
Shrine **50**

Kanda Myojin
Shrine **27**

Ochanomizu

Asakusa Line

Hanzomon Line

Kinshi
Park

Akihabara

Asakusabashi

Ryogoku Kokugikan

Chiyoda Line

48

Iwamotocho

Edo-Tokyo
• Museum

Sumida Hokusai
• Museum

JR Sobu Line

Kinshicho

Kameido

Marunouchi Line

Ryogoku

Morishita

Shinjuku Line

Sumiyoshi

Kanda

Hibiya Line

Kodenmacho

Sarue Onshi
Park

Mitsukoshimae

Hamacho

Ningyocho

Otemachi

Suitengumae

Kiyosumi-
shirakawa

• Fukagawa Edo Museum

Ginza Line

Nihonbashi

Tokyo

51 Kiyosumi Gardens

1000 ft

Kayabacho

FUKAGAWA

44 Iriya Asagao Festival / Iriya Kishimojin Temple (p 64)

1-12-16, Shitaya, Taito-ku, Tokyo 110-0004

🚇 Iriya (Hibiya Line) 🚶 1 min. Uguisu-dani (JR Yamanote Line)

🚶 3 min., 5am–11pm, 3 days in early July

🖥 gotokyo.org/en/spot/EV054/

45 Senso-ji Temple / Asakusa (p 38)

2-3-1 Asakusa, Taito 111-0032, Tokyo

🚇 Asakusa (Ginza / Asakusa / Tobu Skytree Lines) 🚶 5 min.

6am–5pm (Kaminari-mon opens 24hours), Open 7 days

🖥 gotokyo.org/en/spot/15/

46 Ueno Park (p 66)

5-20 Ueno Koen Taito-ku Tokyo 110-0007

🚇 Ueno (JR Yamanote / Ginza / Hibiya Lines) 🚶 2 min. Ueno
Okachimachi (Oedo Line) 🚶 5 min. Keisei Ueno (Keisei Line)

5am–11pm, Open 7 days

🖥 japan.travel/en/spot/1673/

47 Mukojima Hyakkaen Gardens (p 84)

3-18-3 Higashi-Mukojima, Sumida-ku, Tokyo 131-0032

🚇 Higashi-mukojima (Tobu Skytree Line) 🚶 8 min.
Keisei Hikifune (Keisei Oshigami Line) 🚶 13 min.

9am–5pm, Open 7 days

🖥 teien.tokyo-park.or.jp/en/mukojima

48 Ryogoku Kokugikan (p 60)

1-3-28 Yokoami, Sumida-ku, Tokyo 130-0015

🚇 Ryogoku (JR Soubu / Oedo Lines) 🚶 2 min.

Sumo Tournaments: 2pm–6pm, 15 days in Jan, May and Sept

🖥 japan.travel/en/spot/1692/

49 Tokyo Kingyo Wonderland / Sumida Aquarium (p 72)

Tokyo Skytree Town "Soramachi" 5-6F

1-1-2 Oshiage, Sumida-ku, Tokyo 131-0045

🚇 Tokyo Skytree (Tobu Skytree Line) 🚶 1 min. Oshiage /
Skytree-mae (Hanzomon / Keisei Oshiage / Asakusa Lines)

9am–9pm, Open 7 days

🖥 sumida-aquarium.com/en

50 Kameido Tenjin Shrine (p 24)

3-6-1 Kameido, Koto-ku, Tokyo 136-0071

🚇 Kameido (JR Soubu Line) E North 🚶 15 min.
Kinshi-cho (JR Soubu / Hanzomon Lines) 🚶 15 min.

6am–5pm, Open 7 days

🖥 japan.travel/en/spot/1702/

51 Kiyosumi Gardens (p 44)

2 to 3 Kiyosumi, Koto-ku, Tokyo

🚇 Kiyosumi Shirakawa (Hanzomon / Oedo Lines) 🚶 3 min.

9am–5pm, Open 7 days

🖥 teien.tokyo-park.or.jp/en/kiyosumi

52 Toyosu Fish Market (p 122)

6-3 Toyosu, Kōtō-ku, Tokyo 135-0061

🚈 Shijo-mae (Yurikamome Line) 🚶 1 min.

5am–5pm, Closed Sundays and some Wednesdays

🖥 japan-guide.com/e/e3013_market.html

53 Kasai Rinkai Park (p 40)

6-2 Rinkaichō, Edogawa-ku, Tokyo 134-0086

🚇 Kasai Rinkai Koen (JR Keiyo Line) 🚶 1 min.

🖥 japan.travel/en/spot/1647/

54 Night Factory Cruise (p 70)

[Keihin Industrial Zone]

🚢 Yokohama - Kawasaki - Ota-ku, Tokyo

Departure from Yokohama Port: 7pm (Summer), 4:30pm (Winter)

🖥 tabione.com/en/factory_cruise

55 Osanbashi Pier / Yokohama (p 142)

1-1-4 Kaigandori, Naka-ku, Yokohama-shi, Kanagawa 231-0002

🚆 Nihon Odori (Minato Mirai Line) 🚶 3 min.

🖥 osanbashi.jp/english

56 Sankeien Garden / Yokohama (p 144)

58-1, Honmoku Sannotani, Naka-ku, Yokohama 231-0824

🚆 Negishi (JR Keihin Tohoku Line) 🚌 10 min. Honmoku (Municipal Bus #58, 99, 101) 🚶 10 min.

🚆 Yokohama (JR Keihin Tohoku Line) 🚌 35 min. Sankeien-iriguchi (Municipal Bus #8, 148) 🚶 5 min.

9am–5pm, Open 7 days

🖥 sankeien.or.jp/en-about/

57 The Great Buddha of Kamakura / Kotoku-in Temple (p 10)

4-2-28, Hase, Kamakura-shi, Kanagawa 248-0016

🚆 Hase (Enoshima Dentetsu Line) 🚶 7 min.

🚆 Kamakura (JR Yokosuka / JR Shonan Shinjuku Lines) 🚌 10 min. Daibutsu-mae (#1 Enoshima Dentetsu / #6 Keihin Kyuko Buses)

8am–5:30pm (5pm Oct–Mar)

🖥 kotoku-in.jp/en

58 Meigetsu-in Temple / Kita-Kamakura (p 56)

189, Yamanouchi, Kamakura-shi, Kanagawa 247-0062

🚆 Kita-kamakura (JR Yokosuka / JR Shonan Shinjuku Lines) 🚶 10 min.

9am–4pm (8:30am–5pm Jun)

🖥 japan.travel/en/spot/1583

59 Tsurugaoka Hachimangu Shrine / Kamakura (p 136)

2-1-31 Yukinoshita Kamakurashi, Kanagawa 248-8588

🚆 Kamakura (JR Yokosuka / JR Shonan Shinjuku Line) 🚶 15 min.

5am–8:30pm (6am–8:30pm Oct–Mar)

🖥 tsurugaoka-hachimangu.jp

60 Zaimokuza Beach / Kamakura (p 118)

5 Zaimokuza, Kamakura-shi, Kanagawa 248-0013

🚆 Kamakura (JR Yokosuka / JR Shonan Shinjuku Line) 🚶 20 min. or 🚌 10 min. Zaimokuza (Keikyu Bus #40)

🖥 japan.travel/en/spot/1589

61 Kugenuma Beach & Enoshima Island (p 68)

4-4 Kugenuma Kaigan, Fujisawa-shi, Kanagawa 251-0037

🚆 Kugenuma Kaigan (Odakyu Enoshima Line) 🚶 10 min.

🖥 japan.travel/en/spot/2096/

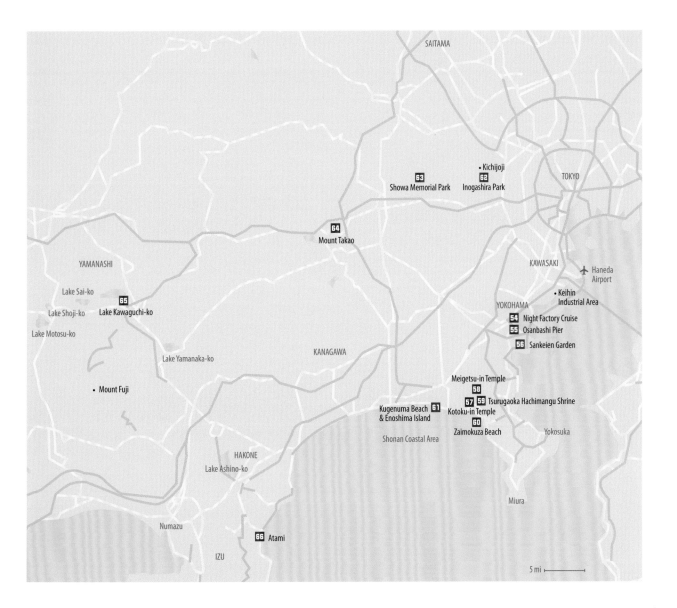

SAITAMA

• Kichijoji

63 Showa Memorial Park **62** Inogashira Park

TOKYO

64 Mount Takao

KAWASAKI

✈ Haneda Airport

YAMANASHI

Lake Sai-ko

• Keihin Industrial Area

Lake Shoji-ko **65** Lake Kawaguchi-ko

YOKOHAMA

Lake Motosu-ko

54 Night Factory Cruise

55 Osanbashi Pier

Lake Yamanaka-ko

KANAGAWA

56 Sankeien Garden

• Mount Fuji

Meigetsu-in Temple

58

57 **59** Tsurugaoka Hachimangu Shrine

Kugenuma Beach **61** Kotoku-in Temple
& Enoshima Island

Yokosuka

60

Zaimokuza Beach

Shonan Coastal Area

HAKONE

Lake Ashino-ko

Miura

Numazu

66 Atami

IZU

5 mi

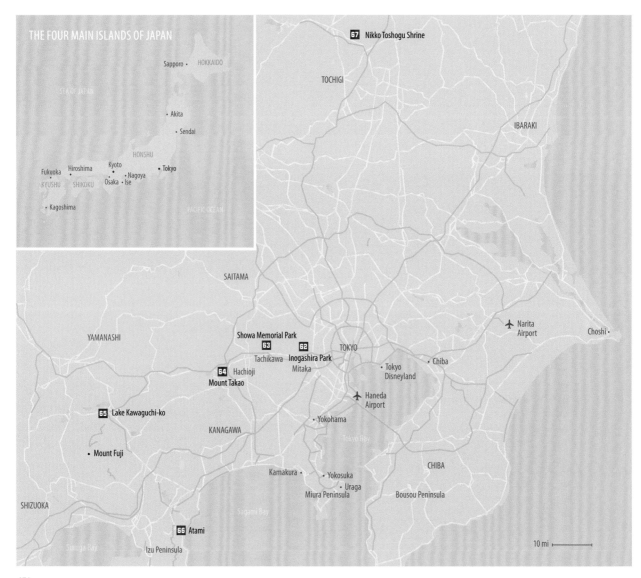

THE FOUR MAIN ISLANDS OF JAPAN

HOKKAIDO

Sapporo •

SEA OF JAPAN

• Akita

• Sendai

HONSHU

Fukuoka • Hiroshima Kyoto
 • • • Nagoya • Tokyo
KYUSHU SHIKOKU Osaka • Ise

• Kagoshima

PACIFIC OCEAN

67 Nikko Toshogu Shrine

TOCHIGI

IBARAKI

SAITAMA

YAMANASHI

Showa Memorial Park
63
Tachikawa

62 Inogashira Park
Mitaka

64 Hachioji
Mount Takao

TOKYO

Narita
Airport

Choshi •

• Chiba

• Tokyo
Disneyland

Haneda
Airport

65 Lake Kawaguchi-ko

KANAGAWA

• Yokohama

Tokyo Bay

• Mount Fuji

CHIBA

Kamakura •

• Yokosuka

• Uraga
Miura Peninsula

Bousou Peninsula

SHIZUOKA

Sagami Bay

66 Atami

Suruga Bay Izu Peninsula

10 mi

OTHER AREAS

82 Inogashira Park (p 98)
1-18-31 Gotenyama Musashino-shi Tokyo 180-0005
🚉 Kichijoji (JR Chuo / Keio Inogashira Line) 🚶 5 min. Inogashira
Koen (Keio Inogashira Line) 🚶 1 min.
🖥 japan.travel/en/spot/1633/

83 Showa Memorial Park (p 32)
3173, Midori-cho, Tachikawa-shi, Tokyo 190-0014
🚉 Nishi-tachikawa (JR Oume Line) 🚶 2 min. Tachikawa (JR Chuo
Line) 🚶 10 min., 9:30am–5pm (4:30pm Nov–Feb, 6pm weekends and
holidays Apr–Sept)
🖥 japan.travel/en/spot/1629/

84 Mount Takao (p 146)
[Takao Baigo] Nishiasakawa-machi / Uratakao-machi,
Hachiōji-shi, Tokyo 193-0841
🚉 Takao (JR Chuo Line) 🚶 15 min. Takaosanguchi
(Keio Line) 🚶 10 min.
Hiking Trails (100min. or less): #1–6, and Inariyama
🖥 japan-guide.com/e/e3029.html

85 Mount Fuji & Lake Kawaguchi-ko (p 110)
[Kawaguchi-ko Station] 3641 Funatsu, Fujikawaguchiko-machi,
Minamitsuru-gun, Yamanashi-ken 401-0301
🚌 Shinjuku Expressway Bus Terminal 105 min.
🖥 japan.travel/en/fuji-guide/

86 Atami Fireworks Display (p 138)
[Atami Shinsui Park]
18 Nagisacho, Atami-shi, Shizuoka 413-0014
🚉 Atami (JR Shinkansen-35 min. / JR Tokaido Line)
🖥 japan.travel/en/spot/164

87 Nikko Toshogu Shrine (p 86)
2301 Sannai, Nikko, Tochigi 321-1431
🚉 Tobu Nikko (Tobu Line-120min.) 🚌 10 min. Nishisando
(Tobu Bus) 🚶 5 min.
8am–5pm (4pm Nov–Mar), Open 7 days
🖥 japan.travel/en/spot/1482/

History of Tokyo and Tokyo Glossaries

江戸
EDO

to

TOKYO
東京

History of Tokyo

The area now known as Tokyo has been inhabited since ancient times. It began as the sleepy fishing village of Edo, centuries before the Edo period began.

Change came in 1603 after a regional warlord, Tokugawa Ieyasu, took control of Japan and established the Tokugawa shogunate there. Then Ieyasu and his heirs forced the regional daimyo lords to finance the expansion of Edo, and for the regional daimyo lords to live in the city during part of every other year. To support the new construction and the vast number of samurai in need of goods and services, merchants, craftsmen and entertainers from all over Japan set up shop in the growing city.

Edo became Japan's center of politics and culture, and grew into a huge city with a population of more than a million by the mid-eighteenth century, about double the size of London at that time. The formal capital of the nation was still Kyoto, however, since that is where the Emperor resided.

The Edo Period lasted for nearly 260 years until the Meiji Restoration in 1868, when the Tokugawa shogunate ended and imperial rule was restored. The Emperor moved to Edo, renamed "Tokyo" (which means "eastern capital") making Tokyo the capital of Japan.

During the Meiji era (1868-1912), Japan began to be influenced by Western styles and ideas. Buildings made of stone and brick were built on the sites of the mansions of feudal lords, and major roads were paved with round stones. A two-story Western-style building known as Rokumeikan, designed by the British architect Josiah Conder, was constructed in November 1883 in present day Hibiya and became a symbol of Westernization. Parties and balls were frequently held there, with foreigners among the guests.

Tokyo then experienced terrible devastations in the Taisho (1912-1926) and Showa (1926-1989) eras.

The first tragedy to befall the city was the Great Kanto Earthquake in September of 1923. Fires caused by the earthquake burned the city center to the ground. More than 140,000 people were reported dead or missing, and 300,000 homes were destroyed.

The second tragedy struck in WWII when Tokyo was bombed 102 times, including an intense air raid on March 10, 1945. Much of Tokyo had been laid waste by the bombings and by October 1945 the population had fallen to 3.49 million, half its level of 1940.

The nation gradually recovered during the 1950s, and during the 1960s to the 1980s Japan's economy grew to become the second largest in the world, in a phenomenon known as the Economic Miracle. When the 1964 Summer Olympics were held in Tokyo, it symbolized that the city had become a full-fledged member of the modern world economy.

What makes Tokyo so fascinating is the fact that not only has it transformed from a sleepy fishing village to the magnificent metropolis where 13 million people now live, but it is also where traditions passed on from the Edo period coexist with the most modern culture of today.

Utagawa Hiroshige, Morning View at Nihonbashi from the series Fifty-three Stations of the Tokaido, 1833-34

Tokugawa Ieyasu

Born in Mikawa province (Aichi Prefecture), Tokugawa Ieyasu (1543-1616) was the last of the three unifiers who put Japan together again after the Warring States Period. During this time, regional warlords were fiercely competing for national domination, so he was forced to spend much of his childhood as a hostage of the Imagawa clan. Ieyasu was the ally and retainer of the other two unifiers, Oda Nobunaga and Toyotomi Hideyoshi. Hideyoshi moved Ieyasu to a large domain with a dilapidated castle in the fishing village of Edo as a reward for his loyal service, and as a means to increase Hideyoshi's control over eastern Japan. It was also a safely remote location for Ieyasu, a powerful, and therefore potentially dangerous retainer of Hideyoshi. After Hideyoshi's death in 1598, Ieyasu quickly took control of the country by winning the Battle of Sekigahara. In 1603, he accepted the title shogun (the supreme military commander) from the emperor and established Tokugawa Shogunate in Edo.

Meiji Restoration (Meiji Ishin)

Leading four "Black Ships" (two steamers and two sailing vessels) armed with 63 powerful cannons, American Commodore Matthew Perry entered Edo Bay on July 8, 1853 and demanded that Japan open its ports to American trade and end its national seclusion policy that had been in place for more than 200 years.

Perry's arrival would soon split samurai lords and activists over how Japan should defend itself from Western powers. Some called for war to drive away the barbarians from the West, while others argued Japan should open up and adopt Western technologies to defend itself.

The ensuing power struggles and civil war eventually led to the collapse of the Tokugawa shogunate and the establishment of a government centered on Emperor Meiji in 1868 that later modernized, industrialized and Westernized the entire country in order to compete with the rest of the world.

Sugawara Michizane

Sugawara Michizane (845-903) was a scholar, poet, and politician of the Heian Period (794-1185).

In 899 he served the Emperor as a trusted Minister of the Right (one of the top ministerial positions) until he fell into disfavor. He was demoted and exiled to Dazaifu in Kyushu Island by the political

Utagawa Hiroshige, Kameido Tenjin keidai (Wisteria at Kameido Tenjin Shrine) from Meisho Edo hyakkei (One Hundred Famous Views in Edo), 1856, *see p24-25*

maneuverings of his rival, Fujiwara Tokihira, in 901. Michizane died in exile in 903.

Shortly after Michizane's death a series of calamities—storms, fires, and violent deaths—were attributed to his vengeful spirit. To placate the spirit, Michizane was posthumously reinstated to high rank and later deified as a *Tenjin*, which means "sky deity."

For the first few centuries, Tenjin was seen as a god of natural disasters, and worshipers hoped to please him and avoid his curses. However, Michizane was also a famous poet and scholar in his lifetime, so in the Edo period scholars and educators regarded him as a patron of scholarship.

Kamakura

Less than an hour south of Tokyo by train, Kamakura is a historic city in Kanagawa Prefecture famous for its temples and literary heritage, as well as its beaches and hiking trails. The Kamakura period in Japanese history (1192 to 1333) is known for when feudalism was firmly established. It was named for the city where Minamoto Yoritomo set up the Kamakura shogunate.

Yamanote and Shitamachi

The historic separation of Tokyo into two distinct regions has persisted even to this day, although the city's boundaries have expanded.

Yamanote (meaning "*mountain hand*"), west of the Imperial Palace, was once a hilly area populated by the rich and the powerful, including *Tokugawa vassals* and the military elite.

Conversely, *Shitamachi* (meaning "lower town" or "downtown"), which includes Adachi, Arakawa, Chiyoda (in part), Chuo, Edogawa, Koto, Sumida and Taito wards, was flat and marshy, and populated by the lower classes of samurai, merchants and craftsmen.

Daimyo

Subordinate to the *shogun*, *daimyo* were powerful feudal rulers from the 10th century to the mid 19th century. In 1871 the domains were abolished and the prefecture system was adopted, and the former *daimyo* were converted into pensioned nobilities.

Noh and Kyogen

Noh is a form of theatre based on song and dance performed by actors wearing masks and beautiful costumes. The story unfolds through spoken word and dance arranged to musical elements. The elements include instrumental music featuring a flute and percussion instruments, as well as vocal music called *utai* (chanting) in which words are set to a tune. The acting and staging are refined, and profound meaning is embodied in even slight movements of the actors. Another distinct element of *Noh* is that the main character is often not a real person, but a ghost or a spirit.

Kyogen is a theatrical performance in which the story unfolds through human conversations. The plot draws on the daily events of the period in which the plays are set, with archetypal characters of the time and setting. Based on satire and comedy, *Kyogen* amusingly depicts strong-willed ordinary people by typifying characters and exaggerating their gestures. Its repertoire is diverse, and may include music and dance.

Noh and *Kyogen* originated from a performing art brought to Japan from China during the Nara period (8th century). In the 14th to 15th centuries Kan'ami and his son Zeami perfected *Noh* into the current form.

Kabuki

Kabuki is a popular traditional Japanese drama with singing and dancing performed in a highly stylized manner. The origin of the name of *Kabuki* is the verb *kabuku*, meaning to be eccentric or extraordinary or outstep the bounds of common sense.

The history of *Kabuki* began in 1603 when Izumo no Okuni, possibly a female shaman of Izumo Taisha at a Shinto shrine in Shimane Prefecture began performing a new style of dance drama in the dry riverbeds of Kamo River in Kyoto that soon became hugely popular and spawned many imitators.

But the "Okuni"-style female *Kabuki* troupes were banned in the mid-17th century by the Tokugawa shogunate for its eroticism. The ban led to the formation of "*yaro*" *Kabuki*, all-male troupes in which actors also played female roles and which became the basis for modern-day *Kabuki*.

The Genroku Period (1688-1704) in the mid-Edo Period is considered *Kabuki*'s golden age, when its structure was formalized, as were many style elements. *Kabuki* became an established and popular art form that was capable of the serious, dramatic presentation of genuinely moving situations. As merchants and other commoners in Japan began to rise

on the social and economic scale, *Kabuki*, as the people's theatre, provided a vivid commentary on contemporary society.

Kabuki continued to flourish through the Edo and the Meiji periods, producing countless original acts and "families" of actors that continue to perform to this day.

and innovative compositions inspired artists such as Claude Monet, Mary Cassatt, Vincent Van Gogh, and Henri de Toulouse-Lautrec.

Ukiyo-e

Literally meaning "Pictures of the Floating World," *Ukiyo*-e refers to a style of Japanese woodblock print and painting from the Edo period depicting popular *Kabuki* actors, beautiful courtesans, city life, landscapes, and erotic scenes. The Floating World, as the pleasure districts of Edo were called, describes the urban lifestyle, especially the pleasure-seeking aspects.

It's commonly said that in Edo, anyone could own a masterpiece *ukiyo*-e print for about the price of a bowl of noodles, since *ukiyo*-e printmakers innovated color printing techniques that made it possible to widely distribute their art.

Some of the greatest ukiyo-e artists from the Edo period are Kitagawa Utamaro, Toshusai Sharaku, Utagawa Toyokuni, Katsushika Hokusai and Ando Hiroshige, and their work also had a profound impact on European Impressionists and Post Impressionists—the flattened perspective

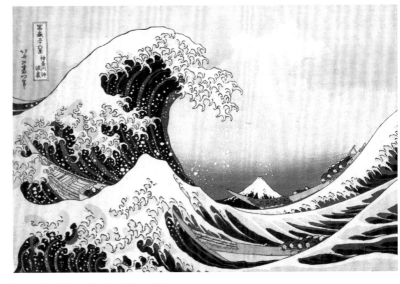

Katsushika Hokusai, The Great Wave of Kanagawa from the series Thirty-six Views of Mount Fuji (Fugaku sanjurokkei), c. 1830-32

INDEX

ARIGATO (Thank you)!

Museyon and misaki matsui would like to thank the many people and institutions who helped in the creation of this book

Tokyo Metropolitan Government
www.metro.tokyo.jp/english/

Japan National Tourism Organization (JNTO)
www.jnto.go.jp/eng/

Japan Arts Council
www2.ntj.jac.go.jp/unesco/noh/en/

Edo-Tokyo Museum
www.edo-tokyo-museum.or.jp/en/

Japan Times
www.japantimes.co.jp

PBS
Japan: Memoirs of a Secret Empire
www.pbs.org/

Encyclopaedia Britannica
https://www.britannica.com/place/Tokyo

Canon U.S.A., Inc.

Ayumi Tsuzuki

Keiko Sasaki

Shuzo Matsui / Akiko Matsui

Cool Japan Series, Book 2
TOKYO MINDSCAPES
Where to Go, When to Go, What to See
Photo and Text: misaki matsui, Editing: Janice Battiste
ISBN 9781940842325

ABOUT MUSEYON

Named after the Museion, the ancient Egyptian institute dedicated to the muses, Museyon Guides is an independent publisher that explores the world through the lens of cultural obsessions. Intended for frequent fliers and armchair travelers alike, our books are expert-curated and carefully researched, offering rich visuals, practical tips and quality information.

For more information vist **www.museyon.com, facebook.com/museyon, twitter.com/museyon** or **instagram.com/museyonbooks.**

Museyon Guides has made every effort to verify that all information included in this guide is accurate and current as of our press date. All details are subject to change.

Cool Japan Series, Book 1
COOL JAPAN
A Guide to Tokyo, Kyoto, Tohoku, and Japanese Culture Past and Present
Sumiko Kajiyama
ISBN 9781940842226